WITHDRAWN

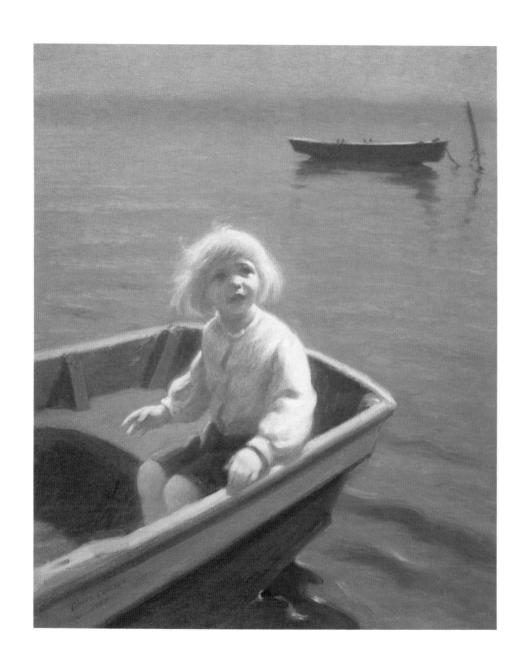

MINNESOTA
IMPRESSIONISTS

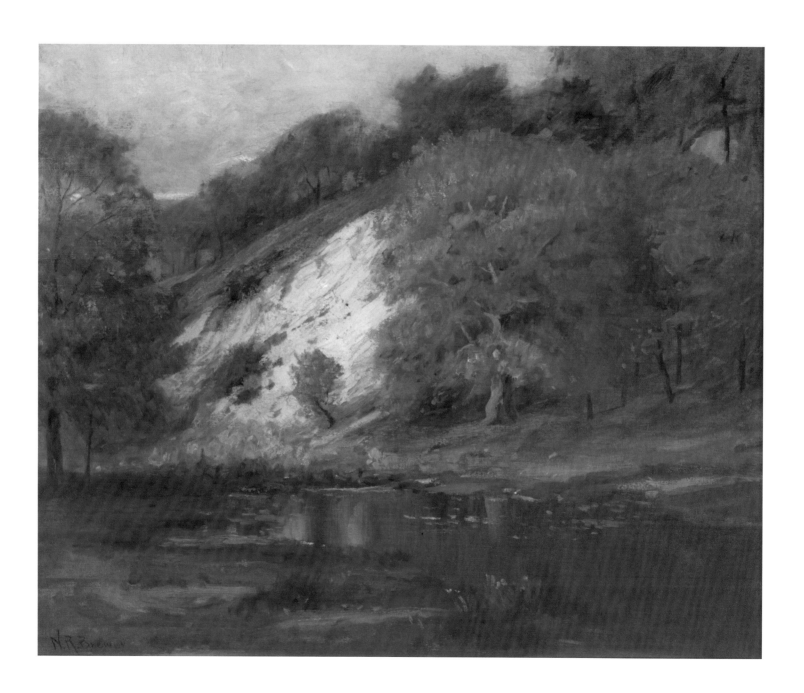

MINNESOTA
IMPRESSIONISTS

RENA NEUMANN COEN

Foreword by
William H. Gerdts

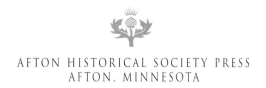

AFTON HISTORICAL SOCIETY PRESS
AFTON, MINNESOTA

Cover and frontispiece: *Root River Country* by Nicholas R. Brewer, undated.
Oil on canvas, 23″ x 30″. Private collection

Half title page: *Morning of Life* by David Ericson.
Portrait of artist's son, David B. Ericson, at age three at a dock on Park Point in Duluth.
Oil on canvas, 27 1/8″ x 22 1/8″. From the George P. Tweed Memorial Art Collection.
The Tweed Museum of Art, University of Minnesota, Duluth

Designed by Barbara J. Arney

Publication of Minnesota Impressionists was made possible, in part,
by a grant from the River Valley Arts Council and a gift from Bruce B. Dayton.

Sarah P. Rubinstein edited the text for this book.
Mary Susan Englund and Michelle Nelson provided production coordination for this project.

Library of Congress Card Cataloging-in-Publication Data

Coen, Rena Neumann.
 Minnesota impressionists / Rena Neumann Coen;
 foreword by William H. Gerdts
 p. cm.
Includes bibliographical references.
1. Impressionists (Art)--Minnesota. 2. Painting, American-
Minnesota. 3. Painting, Modern--20th century--Minnesota.
I. Title.
ND230.M6C63 1996
759,176'09'041--dc20 96-36446
ISBN 0-9639338-6-8 (alk. paper) CIP

Printed and bound in Canada

The Afton Historical Society Press is a non-profit organization that takes
great pride and pleasure in publishing fine books on Minnesota subjects.

W. Duncan MacMillan Patricia Condon Johnston
president publisher

AFTON HISTORICAL SOCIETY PRESS
P.O BOX 100
AFTON, MN 55001
612-436-8443

TABLE OF CONTENTS

FOREWORD 8

ACKNOWLEDGMENTS 10

INTRODUCTION 11

ARTHUR R. ALLIE 19

GERTRUDE BARNES 21

NICHOLAS RICHARD BREWER 24

SAMUEL CHATWOOD BURTON 28

ELISABETH AUGUSTA CHANT 31

EDWIN M. DAWES 35

AXEL DAVID ERICSON 37

ALEXIS JEAN FOURNIER 41

ANTON GAG 45

HERBJØRN GAUSTA 48

ALEXANDER GRINAGER 51

SVEN AUGUST (KNUTE) HELDNER 54

ALICE HÜGY 58

LOUISE KELLY 61

ROBERT KOEHLER 63

ALICE SUMNER LE DUC 67

PHILIP LITTLE 71

CLARA MAIRS 74

HOMER DODGE MARTIN 78

MAGNUS NORSTAD 81

NATHANIEL POUSETTE-DART 83

CARL WENDELL RAWSON 86

CLARENCE CLARK ROSENKRANZ 89

ADA AUGUSTA WOLFE 92

FOR FURTHER READING 95

ALEXIS FOURN

FOREWORD

*I*MPRESSIONISM, however we may define the term, was an aesthetic born in France in the 1870s. Harbingers of the movement can be found earlier, not only in that country but also elsewhere in Europe, particularly in England where John Constable and Joseph Turner have been identified (especially by English critics!) as precursors of the French Impressionists. Even the brightly colored pictures of the Pre-Raphaelites, painted out-of-doors in the late 1840s and 1850s, can be interpreted as utilizing strategies later identified with the French movement.

In turn, Impressionism spread quickly, though not uniformly, through the Western world and even to Japan by the end of the nineteenth century. A few French Impressionist paintings were seen in the United States even in the late 1870s, but the decisive stage for the introduction of the movement to Americans and among American artists can be pinpointed to the years 1886–1887. In the spring of 1886, the American Art Galleries in New York City held an exhibition of about three hundred paintings sent to this country by the Parisian dealer, Paul Durand-Ruel, the vast majority of which were by the French Impressionists whose works he handled. A show of such quality and magnitude could not be reassembled today. American critical reaction was immediate, and though mixed, it thoroughly established awareness, understanding, and in many circles, approbation of the innovations of Impressionism. Impressionist influence could be seen almost immediately in the urban park scenes painted in Brooklyn that summer by William Merritt Chase. The following year, 1887, a group of American artists founded an art colony in Giverny, France, where Claude Monet had been living for the past four years. There, Impressionism thrived for over thirty years, attracting artists from many nations but primarily from the United States.

The majority of these artists returned to America, fully committed to the tenets of Impressionism, which spread throughout the country. Numerous summer art colonies—replicants of Giverny—developed across the land, from Old Lyme, Connecticut, to Laguna Beach, California. But just as in European nations where the embrace and development of Impressionism was not consistent, so, too, in the United States. Artists in the New York area and in communities along the Connecticut shore adopted Impressionism with much more enthusiasm than those in Philadelphia. Southern California artists, for a number of reasons including climate, tradition, and population patterns, subscribed to Impressionism to a far greater degree than those painters working in the Bay Area, whose commitment to the poetics and close harmonies of Tonalism remained dominant. And in the Pacific Northwest, Impressionism appears to have made little headway at all.

The observation regarding the Northwest may change, of course, when art historians delve deeper into the early twentieth-century history of art developments in Oregon and Washington, which have so far been pretty much overlooked. I have just become aware of the work of John Butler, a Seattle artist who studied with Chase, who was engaged in his final season of summer teaching in 1914, this time at Carmel, California; Butler subsequent-

ly won first prize in a Northwest Artists exhibition in his native town for a painting fully Impressionist in both style and subject. My point here is that the history of the Impressionist movement, not only in the Northeast but in Indiana, in Ohio, in California, and to a lesser degree in the South, has been resurrected by scholars, while other areas have been for the most part ignored—perhaps due to the sparseness of that history, or perhaps not.

Impressionism in Minnesota has constituted such a lacuna until now, and Rena Coen, the foremost historian of art in the state, is certainly the scholar to have undertaken such a study. She rightly points out the difficulties in such an undertaking, which accounts for our ignorance of this history until now. While Minneapolis and St. Paul constituted (and continue to constitute) an urban center for the development and exchange of cultural ideas, the Impressionist movement had no base or individual leader around whom those utilizing its aesthetics could congregate, as the Northeast had The Ten American Painters, Indiana, the Hoosier Group, or Southern California such dominant individuals as William Wendt and Guy Rose. Artistic development in Minneapolis centered more around the Arts and Crafts movement, which did not particularly embrace Impressionism, while the dominant artist-teacher of the period, Robert Koehler, was a painter working within a Tonalist mode. Moreover, many of the finest of Minnesota Impressionists either left the state before they adopted the strategies of Impressionism, as did Alexis Jean Fournier (for East Aurora, New York), or soon thereafter, as did Alexander Grinager.

Grinager's *Boys Bathing* of 1894 is today perhaps the best-known Impressionist image to emerge from Minnesota, but two years later he moved permanently to Ossining, New York, and at least today, his career is totally obscure. I have recently come across a reference to Grinager's involvement with an art colony in the Ossining-Tuckahoe, New York, area, probably itself allied with the artists' colony in nearby Bronxville, and it has brought back to me the question as to whether had he, and maybe Fournier, remained in Minneapolis, Impressionism might have found a more solid and enduring foundation there. Grinager and Herbjørn Gausta, for instance, were quite good friends, and perhaps a true Impressionist art colony might have developed. As it stands, Nicholas Brewer would seem to be the most consistently Impressionist of the longtime resident artists in the city, but his professional priorities lay, necessarily, in his more academic, conservative portraits.

Another factor that Dr. Coen's study reveals is the diversity of aesthetic concerns even among those painters whose works can be classified as "Impressionist," from the more orthodox strategies of Brewer's landscapes to Gausta's impressive naturalism, the modified Barbizon approach of Knute Heldner, and the almost mystical overtones of the painting of David Ericson. Finally, Dr. Coen has worked heroically to unearth a good number of heretofore forgotten Impressionists, such as Clarence Rosenkranz, Carl Rawson, and Magnus Norstad, the last a specialist in sparkling winter scenes, a subject naturally reflecting the Minnesota environment. And she has brought to light a number of women adherents, such as Gertrude Barnes, Alice Hugy, Louise Kelly, and perhaps, particularly, Ada Wolfe. In the art of all these painters, a new chapter has been opened in the history of art in Minnesota.

WILLIAM H. GERDTS
PROFESSOR OF ART HISTORY
GRADUATE SCHOOL OF THE
CITY UNIVERSITY OF NEW YORK

ACKNOWLEDGMENTS

A NUMBER OF PEOPLE HAVE been helpful in the research involved in writing this book. First and foremost, I owe a debt of gratitude to Thomas O'Sullivan, Curator of Art at the Minnesota Historical Society, who, besides taking me through the Historical Society's art collection, also generously opened his curatorial files to me. This book could not have been written without his help. Karen Duncan, registrar, and Shawn Spurgin, assistant registrar, of the Weisman Art Museum at the University of Minnesota showed me relevant paintings in that museum's collection. Gerald Czulewicz of Antiques Americana in Bethel, Minnesota, and Gerald Johnston of Minneapolis have my thanks for bringing works by obscure artists to my attention. Richard Beard Thompson of the Beard-Carver Art Gallery and Wesley and Leon Kramer of the Kramer Art Gallery, both in Minneapolis, were also very helpful. So was the Reverend Richard Hillstrom, art curator of the Lutheran Brotherhood in Minneapolis and a collector of note. Anne Brennan, curator of St. John's Museum, Wilmington, North Carolina, was a big help in providing material on Elisabeth Chant. Similarly, Michael Wodnick of St. Paul showed me a work I had been unaware of by Alexis Jean Fournier. Peter Spooner, art curator of the Tweed Art Gallery at the University of Minnesota at Duluth, took the time to show me through the gallery, noting particularly the work of Knute Heldner. Jan Voogd, reference librarian of the Essex-Peabody Museum in Salem, Massachusetts, was helpful in my research on Philip Little, as was Joel D. Seimler, manager of Special Collections at the American Museum of Natural History in New York, with regard to Clarence Rosenkranz. Others whose help I appreciate are Susan Meehan and the staff of the research center of the Minnesota Historical Society, who provided help that was always cheerfully and promptly given. Finally I am grateful to Patricia Condon Johnston, publisher of the Afton Historical Society Press, for suggesting this work to me in the first place and for her constant encouragement along the way. To all of them, I extend my thanks with the observation that whatever sins of commission or omission may be found in this book are mine alone.

INTRODUCTION

O N MAY 15, 1863, an exhibition opened in Paris to show the paintings of a group of French artists whose work had been rejected by the aridly academic but official Salon of that year. Called the "Salon des Refusés" (The Salon of Those Refused), this independent show included paintings with such titles as *Impressions of a Forest* or *Impressions of a Sunrise*. Contemporary critics, contemptuous of the new style, derisively called the group of artists "Impressionists." At first glance the Impressionists' paintings seemed to those critics to be just crude sketches, rough and shapeless color plans of a scene, rather than the well-defined and smoothly polished pictures to which they were accustomed. The Impressionists had, in fact, discovered that the division of the paint into dabs of pure color produced a more intense effect than if those colors were mixed on the palette before applying them to the canvas. Seen from a distance, the divided colors fused in the observer's eye, resulting in a lively and vibrant effect, as though the pictured scene were being perceived at first hand in the out-of-doors. The Impressionist painters, in a departure from tradition, even took their canvases out into the open air, "en plein air" as the French called it, the better to observe the effects of light and shadow on the colors of the natural world. In doing so, they subordinated sentiment and preconception to purely visual phenomena, capturing with a loose and rapid brush stroke the light and color of the out-of-doors. "I simply follow the light, where it comes from, where it goes," wrote the American Impressionist Frank W. Benson,[1] and indeed for all the Impressionists, light was not only the basis of color but of the creation of form as well. And if the shimmer of light seemed to dissolve solid shape in the pictured scene, its effect was nevertheless the paramount goal in a new kind of pictorial form. It was only the perception of form as the product of light and shadow, these artists felt, that would lead to an objective examination of the external world and a truthful record of the infinite variations of subjective experience.

Since the Impressionists were chiefly concerned with the appearance of things without the idealization characteristic of most contemporary academic painting, an idealization that gave a feeling of permanence and stability to the finished picture, they defined their casual, seemingly accidental subjects in temporary and instantaneous terms. This rapid approach to Impressionist pictorialization had the further effect of suggesting the heightened tempo of late-nineteenth-century life, like the fragmentary and fleeting view of the world that one gets from a bus, a train, or any other rapidly moving conveyance. For engine-driven vehicles, which had made their first appearance in the early part of the nineteenth century, had by the end of it become such a common feature of everyday life that the view from them had become a part of many artists' visual vocabulary.

In the work of the master painters of the new Impressionist movement in France, the principles of the style received their definitive expression. Camille Pissarro, Claude Monet, Pierre Auguste Renoir, Alfred Sisley and to some extent Edouard Manet and Edgar Degas painted in the open air and divided their color into pure hues, unmixed on the palette and applied directly to the canvas. In

a truly Impressionist painting, each color, separately visible, gives the illusion of the flickering light and vibrant atmosphere the artists pursued. The effect was heightened by the thick impasto they frequently used, as well as by their loose and sketchy brush strokes. Moreover the practitioners of the new style abolished the color black, maintaining that since black implies the absence of light it does not exist in nature and therefore has no place in a painted representation of it. The casual, everyday appearance of things—the slice of life as it has been called—that they captured with their seemingly unstudied spontaneity had the result of evoking the artist's, and through the artist the viewer's, presence in the pictured scene, making the pictorial representation all the more vivid, personal, and immediate.

During the last two decades of the nineteenth century, the theory and practice of Impressionism spread to every nation of the western world, and by the mid-1870s, many American painters were, at the very least, aware of the new development in France. The United States was especially receptive to the new style since, after the Civil War, a growing cosmopolitanism characterized American culture, and American artists, by and large, were willing to abandon their earlier nationalistic aims to join their European colleagues in seeking common goals and common means of pictorial expression.[2] Moreover starting in the 1860s, American students by the thousands began to receive training in art in France, especially at the École des Beaux-Arts or at independent art academies such as the Académie Julian or the Académie Colarossi. Paris was universally recognized as the center of the art world both for training in art and for the much sought-after goal of having one's work exhibited at the annual Salon there, to be noted, one hoped favorably, by the critics and the public.

The spread of Impressionism in America was un-doubtedly fostered also by the strength of its own landscape tradition throughout the nineteenth century. That tradition took different forms, from the tightly painted allegorical landscapes of Thomas Cole and his followers in the Hudson River School to the unpretentious genre country scenes of Asher B. Durand and from the dramatic panoramas of Frederic E. Church and Albert Bierstadt to the dreamy visions of George Inness. All of them, however, depicted nature with respect, admiration, and even the conviction that God himself had blessed the New World, this virgin land, with a special creative urge. That divine urge had a moral value for them as well, for they believed that America, far as it was from what they saw as the intrigues and corruption of Europe's tired societies, was the location of a new Eden where man could live a truly virtuous life in simple harmony with nature.

This essentially Rousseauian view of God's benevolent purpose for the New World was also expressed by the Luminist landscape painters of the mid-nineteenth century, of whom Fitzhugh Lane, John Kensett, Martin Johnson Heade, and Sanford Gifford are the best known. Their fondness for reflected light on still and tranquil bodies of water or on the marshes of the Northeast was not only a manifestation of Ralph Waldo Emerson's transcendentalism, a mystical fusion of God and nature, but a pantheistic investigation of light as a spiritual demonstration of that fusion. Indeed it was light that confirmed for these artists the sense of infinite life in all matter, of God in nature and nature in God. Thus in terms of light, as well as a reverence for the natural scene, America's painters were prepared to receive the message of Impressionism together with its celebration of the out-of-doors.

In addition to light as a symbolic visual force, an interest in color and its chromatic variations under different atmospheric conditions also informed the work of nineteenth-century landscapists in the United States.

Undoubtedly this admiration for color and its permutations in natural light further helped to create a fertile ground for the tenets of Impressionism to take root in America.

Sometimes the Impressionist aesthetic was applied not to the local landscape but to such subjects as still life or portraits. In these cases it is the use of Impressionist color or its sketchy, loose brushwork that identifies the work as essentially Impressionist. By and large it was the women artists who, although they painted landscapes, too, used Impressionist techniques to depict nonlandscape themes. They were, of course, just as familiar as their male colleagues with French Impressionism, but custom and social pressure frequently kept the female artists indoors where "safe subjects" like still life could be arranged, studied, and painted within the sheltered confines of the home.

Of course, not all American painters agreed with the Impressionist tenets. One of the first American artists to look closely at Impressionism was George Inness. He did not like the new style, claiming that it "ignored the reality of the unseen."[3] He had spent a year in Paris in 1874–1875 and found Impressionism antithetical to his belief in the spiritual interpretation of landscape and reality itself, and the new classicism that characterized his work during the 1870s was diametrically opposed to Impressionist ideas. On the other hand, Mary Cassatt, one of the foremost American Impressionists, was a friend and protégé of Edgar Degas, and she lived and worked for many years in France. In her handling of color, her tendency to crop the view of her subject, as well as in her devotion to the casual and incidental scene, she was at one with the Impressionists. Nor was she alone. Other American artists who followed the French Impressionists included Childe Hassam, John Twachtman, William Merritt Chase, John Alden Weir, Willard Metcalf, Edmund Tarbell, and Frank Benson.

Minnesota painters, like those in other parts of the country, participated in the Impressionist movement. That style is present, whether as a temporary phase of their work or as a constant aspect of it, in the work of such artists as Nicholas Brewer, Alexis Jean Fournier, Edwin Dawes, Knute Heldner, and Herbjørn Gausta, a Norwegian-American painter not usually thought of as an Impressionist. These and other "Minnesota Impressionists" lived in the state for various lengths of time, some staying briefly in the area and others spending their entire lives in it. A "Minnesota artist" is thus loosely construed to include any artist who lived in Minnesota for a significant period of time or otherwise identified himself or herself with the region. Thus Alexis Jean Fournier, for example, who lived most of his adult life in East Aurora, New York, and in Indiana, still considered himself a Minnesotan, and throughout his life he returned periodically both to visit and to exhibit his work at the Beard Gallery on Nicollet Avenue in Minneapolis.

But however much these Minnesota artists may have identified themselves with their home state, there is no coherent or common style to which the term "Minnesota Impressionism" might be applied, or which would tie these regional painters one to another in a distinct and recognizable way. All of them painted in an Impressionist mode but each with his or her own highly individual characteristics. They were all, of course, aware of the French Impressionist movement that they adopted, some more, some less, to suit their own artistic purposes. But, unlike their French models, they never exhibited together as a group, nor were they, generally speaking, rebels against an established academic tradition. Moreover they were a far less homogeneous fraternity than the Frenchmen had been.

Some of the Minnesota painters including David Ericson and Knute Heldner were immigrants from Scandinavia or elsewhere in Europe, and most of the rest were second-generation Americans. By and large, they came

from farming families who were pioneers in the frontier Midwest. They were not, as the French Impressionists were, urban members of long-established families that had lived in their homeland for many generations. A sense of independence, therefore, marked the Minnesota Impressionists, whose separateness and personal self-con-sciousness set them apart from the French artists who pro-vided their inspiration and perhaps even from the American Impressionists of the eastern states. The Minnesotans, American Impressionists all, used the French style in their new land, but they never formed a distinct group that was conscious of its common regional back-ground or that was, in any way, reflective of it.

Nevertheless, the Minnesota Impressionists brought to the region a new way of looking at nature and nature's light. Magnus Norstad, Philip Little, Nicholas Brewer, and Edwin Dawes, for example, applied Impressionism's loose brushwork and keen sensitivity to the snowy scene and frigid air of a typical Minnesota winter, as in Brewer's *Winter Scene, Minnesota, Train in Snowy Landscape.* Herbjørn Gausta and Alexander Grinager, on the other hand, painted Impressionistically the glaring sunlight of a summer day in their pictures entitled *Minnesota Farm Scene* and *Boys Bathing*, respectively. Night scenes are not unusual in Minnesotans' paintings, as Arthur Allie's *St. Paul by Night* or S. Chatwood Burton's *Christmas Eve on the Flats* amply testify; both artists painted with the sketchy brush that distinguishes the Impressionist style and separates it from other artistic movements. A favorite Impressionist subject, the domestic summer garden, is vividly portrayed in Nicholas Brewer's *Garden in Winona*, Clara Mairs's *Girl in Garden*, and Alice Hügy's *Garden*. Indeed, Hügy and Mairs, with their even broader brushwork and bolder col-ors, can well be grouped with the post-Impressionist artists. Similarly, the little-known but well-accomplished artist, Alice Le Duc, in her untitled painting of a sunlit field

beside a shadowy outbuilding, evokes the Impressionist "glare esthetic," so well defined by art historian William H. Gerdts.[4]

Some of the Minnesota Impressionists, especially Homer Dodge Martin who painted a Minnesota *Forest Scene* and Alexis Jean Fournier whose *South Bend Bridge in Autumn* is entirely Impressionistic, had spent considerable time in France, living there and painting the French coun-tryside. They were well acquainted at first hand with the French Impressionist movement and even with some of its original masters. Local artists who had not visited France themselves could view the French Impressionist art that was increasingly being shown in American cities at the end of the nineteenth and the beginning of the twentieth centuries. Many Minnesota artists were undoubtedly in-tellectually stimulated and professionally encouraged by an exhibition of ninety-eight French Impressionist paint-ings that was shown in the Minneapolis Public Library's Fine Arts Gallery from April 24 to May 8, 1908. The exhi-bition was circulated by the New York branch of the Durand-Ruel Gallery of Paris, the first to exhibit French Impressionist art in the United States, in a show that opened in New York on April 10, 1881. It proved to be so popular that it was moved to the National Academy of Design where it reopened six weeks later. It received ex-tensive critical coverage and marked the beginning of a se-rious interest on the part of American collectors in acquir-ing Impressionist paintings.

After the watershed Durand-Ruel exhibition, the World's Columbian Exposition held in Chicago in 1893 displayed a number of American Impressionist pictures in its Art Gallery. John Twachtman, Childe Hassam, Mary Cassatt, Theodore Robinson, and Frank Benson were among those represented there although, curiously, the French sec-tion of the Exposition ignored its own Impressionist painters. One had to go to a separate display, a *Loan*

Collection of Foreign Works from Private Galleries in the United States, to see works by Pissarro, Monet, Manet, Degas, Renoir, and Sisley. The Impressionist paintings, by both American and French artists, were, however, not a major part of the art exhibitions that tended toward the more traditional and academic. Nevertheless the Impressionist paintings attracted a disproportionate share of attention on the part of the fairgoers, both the public and the critics. Although not all of the critics were receptive to the new style, many of whom called it the "modern style," they still exerted, through their writings, a significant influence on American artists of that era.

Long before the Durand-Ruel Gallery exhibited Impressionism in Minneapolis, however, and, in one case at least even before Impressionism as a separate and recognizable style was born in France in the 1860s, paintings in an Impressionist mode were being produced in Minnesota.

Like French Impressionist pictures, they were painted out-of-doors in a direct confrontation with nature, depicting the natural scene with dabs of pure color or with a broad and sketchy brush stroke loosely applied to the canvas. They also demonstrated an awareness of the effects of light and atmosphere on the outdoor scene, although rather than the meadows and gardens of France or the boulevards of Paris, it was the forests, lakes, and waterfalls of Minnesota that captured their imagination and their brush.

One of these "pre-Impressionists" was George Catlin (1796–1872), who was born in Wilkes Barre, Pennsylvania, and who in 1832, 1835, and 1836 visited the area that later became Minnesota. He made it his life's mission to record for posterity the American Indian, whom he saw as a doomed and vanishing race. His urgency to depict Indian life in all its aspects before it had completely disappeared led him to employ a rapid, loosely sketched technique

George Catlin, *View on the St. Peter's River, Sioux Indians Pursuing a Stag in Their Canoes*, 1836-1837
Oil on canvas, 19 1/2" x 27 5/8"
National Museum of American Art, Smithsonian Institution, Gift of Mrs. Joseph Harrison, Jr.

while he traveled through the West with his paints and brushes always close to hand. A typical example of his work, painted in 1835, is *Sioux Hunters Pursuing a Stag in the St. Peter's* [Minnesota] *River*. The subject seems to be quickly caught on the canvas, vividly suggesting an out-of-doors event seized immediately at the moment it occurred. It captures the concentration of the hunters in the two canoes as they pursue their quarry, whose head and antlers are visible above the water. A similarly fluid brush stroke defines the shoreline and the distant hills on which the strong light of a summer afternoon shines and glints

off the trees in an Impressionistic evocation of the transience of human experience in nature's ever-changing arena.

More commonly, however, it was the landscape itself that was depicted by these early painters who visited Minnesota, usually on summer sketching expeditions seek-

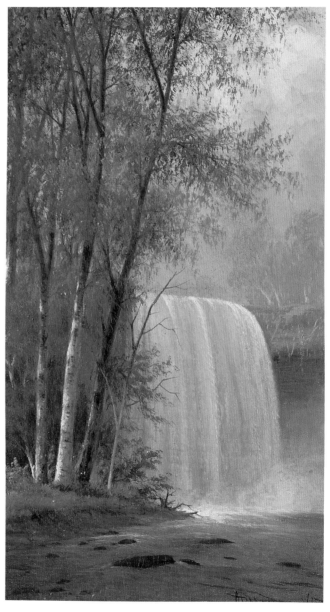

Jerome B. Thompson, *Minnehaha Falls*, 1870
Oil on canvas, 24″ x 17″
Collection Frederick R. Weisman Art Museum
University of Minnesota, Minneapolis

Joseph Meeker, *Minnehaha Falls*, 1879
Oil on canvas, 14″ x 8 1/4″
Minnesota Historical Society

ing "picturesque" subjects for their brush. The river bluffs near Winona, the widening of the Mississippi River at Lake Pepin, and above all Minnehaha Falls were the main attractions for these artist visitors, as they were also for the ordinary tourist of that time. Indeed the fame of Minnehaha Falls, which had been spread worldwide by the publication in 1854 of Henry Wadsworth Longfellow's epic poem, The *Song of Hiawatha,* stimulated a lively tourist interest in the falls that bore the name of the poet's heroine. One view of Minnehaha Falls was painted in 1870 by Jerome B. Thompson (1814–1886) in what is an early version of the Impressionist style. Thompson was born in Middlebury, Massachusetts, and as a young man painted in Barnstable on Cape Cod, later establishing a studio in New York City. He must have known Longfellow's poem and admired it, for among a number of Indian themes he painted was one of *Hiawatha's Journey.* It may well have been his interest in Indian subjects that made him come to

Minnesota where he bought a farm in the pioneer community of Crystal, although he maintained his studio in New York. Thompson had visited Europe in the 1850s and spent some time in England where he very likely had seen, and been influenced by, the landscapes of John Constable, an English artist who was a pre-Impressionist in his evident interest in the effects of light and shadow on the ephemeral outdoor scene. In his painting of Minnehaha Falls, Thompson was able to capture the glint of sunlight in nature and, like Constable and the later French Impressionists, to convey the effect of that light on the outdoor scene through quick dabs of pure, bright color applied directly to the canvas. His representation of the falls captures the cataract of leaping water flashing and glistening in the sun with all the immediacy and sense of "being there" that characterized French Impressionist art.

Joseph Rusling Meeker also painted pre-Impressionist views of Minnesota. Meeker (1827–1889) was born

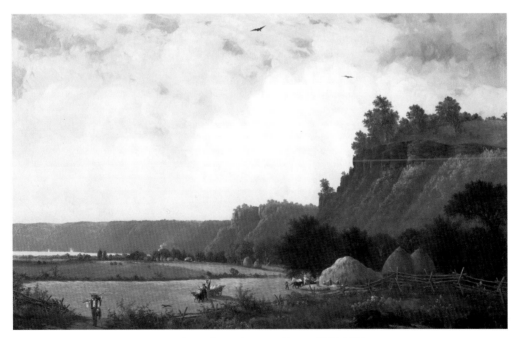

Joseph Meeker, *Minnesota Harvest Field,* 1877
Oil on canvas, 22³/4 x 40"
Minnesota Historical Society

in Newark, New Jersey, was educated at the National Academy of Design in New York, and was a resident of St. Louis, Missouri, after 1859. He is chiefly known for his paintings of the lower Mississippi River in the pale light of its still and shadowy swamps, its bayous dripping with Spanish moss. These pictures graphically suggest the heat and humidity of that part of the river. But Meeker visited the upper Mississippi area, too, on regular excursions he took in the summertime from his home in St. Louis. On one such occasion he painted *Minnehaha Falls* with a freshness and spontaneity not always present in his work.

Another painting, however, that records Meeker's summer visits to Minnesota, is similar to early French Impressionist landscapes in its strong light-and-shadow contrasts, particularly as it is seen in the early works of Camille Pissarro, painted in the countryside near Paris in the 1860s. Meeker's *Minnesota Harvest Scene* of 1877 depicts a wheat field in the southeastern part of the state near Lake Pepin and the town of Winona. The rocky bluffs that are a distinctive feature of the landscape there tower above the wheat field, which is bathed in the golden light of a late summer afternoon. The colors are not loosely brushed in, but they are clear, bright, and distinct in the enveloping atmosphere of a sunny afternoon. Meeker himself

is seen as a small figure holding his artist's equipment as he walks away from the field, his day's work done. A happy note of boundless optimism is sounded in this radiant scene, for it seems to suggest the golden opportunities waiting to be reaped in this rich and fertile river valley. Moreover in its success in placing us in direct relationship to the pictured scene through the depiction of the artist himself (as though we had been in the field with him), the painting captures that sense of personal participation in that time in that place that was also the goal of the French Impressionist painters. Like them, Meeker held strongly to the belief that the landscape painter should work directly from nature in the out-of-doors, where the macrocosm of the real world in all its infinite details could be distilled into the microcosm of the artist's canvas.[5] And even though Meeker may never have seen a French Impressionist painting, his insistence on the primacy of the direct experience of nature rather than a studio representation of it, worked later from memory, reveals his kinship with the Impressionists. The time was ripe on both sides of the Atlantic, and even well into the American Midwest, for a new attitude toward nature and a new intimacy between the painter and the inspiration of the out-of-doors.

NOTES

1. Frank Benson to his daughter, quoted by Faith Andrews Bedford, "Frank W. Benson, The Divided Paintings," *American Art Review* 7, no. 4 (August–September 1995): 106.

2. For a thorough discussion of this aspect of Impressionism, see William H. Gerdts, *American Impressionism* (New York: Abbeville Press, 1984), 23.

3. "Mr. Inness on Art Matters," *Art Journal* (New York) 5 (1879): 374–377, quoted in Gerdts, *American Impressionism*, 30.

4. Gerdts, *American Impressionism*, 17–21.

5. In an article published in the *The Western* in 1878, Meeker wrote about the English artist, Joseph Mallord William Turner, whose paintings, in their focus on light and atmosphere make them also pre-Impressionist, that "from the time he [Turner] first put pencil to paper, he went to nature . . . so that his pictures are miracles of truthful detail." But Claude Lorraine's paintings of mythological and historical events placed in idealized landscapes, painted in the seventeenth century but influential in the nineteenth century, were, Meeker went on, "mere studio compositions and were manufactured like so much marketable ware. . . . He never dreamed that there was any other way to represent nature than through the conventions begotten of his own brain." Such a criticism of a much revered Old Master, one who, incidentally, much influenced the American Hudson River School, was yet another link tying Meeker to the French Impressionists.

ARTHUR R. ALLIE
1872–1953

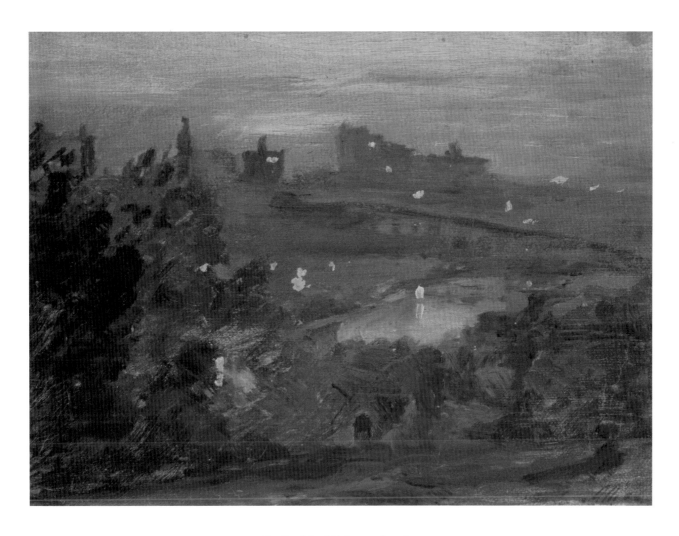

St. Paul by Night, undated
Oil on board
8 3/8" x 11 1/4"
Minnesota Historical Society

ARTHUR R. ALLIE, one of Minnesota's more obscure painters, was born in DePere, Wisconsin, on May 20, 1872. After studying briefly in New York with Robert Henri, a leader of the early twentieth-century artistic fraternity known as "The Eight," Allie returned to St. Paul where he lived for the rest of his life.

Allie is known mostly for his work in the 1930s and early 1940s for the Works Progress Administration and the

Federal Arts Project (WPA/FAP). President Franklin Roosevelt and his administration saw the WPA/FAP program not only as a means of helping artists earn a living at a time when there was little private patronage for the arts but also as a way of encouraging an appreciation of art in American culture. The WPA/FAP artists, by and large, avoided the European avant-garde trends that had been known in the United States since the exhibition of modern art held in the New York Armory in February 1913. Indeed many of those trends, such as cubism, fauvism, German expressionism, Italian futurism, and even surrealism, had already become known to American artists, who had encountered them while traveling in Europe. The WPA/FAP artists saw it as their mission to encourage an intersection of art and life and to portray America and its familiar landscape in an honest and straightforward manner rather than try to keep up with modernist European trends. The WPA/FAP artists in Minnesota, as well as in the rest of the country, were encouraged to participate in "the first true portrait of America" and to produce an "artistic record of the nation's varied people and places by the artists who knew those subjects best." Thus Minnesota artists and their colleagues embraced "the Regionalist American scene as an approach to art that was easily recognizable as an image of everyday life."[1]

Within those rather vague guidelines, however, the WPA/FAP artists worked in styles that ranged from a meticulous realism to rather broadly brushed and simple forms that typified a good deal of the painting of that period. Although cubism as a defined style was generally absent from their work, the solid shapes and strong patterns of their compositions showed at least an awareness of what the avant-garde artists were attempting to do.

In view of Allie's later participation in FAP and his adherence to its underlying tenets, it is something of a surprise that in his earlier career he painted such an Impressionistic landscape as his small picture of *St. Paul by Night*. In a loosely brushed manner, with many of the forms obscured by the nighttime sky, the artist suggests, rather than precisely delineates, the view of St. Paul from the West Side river bluffs. The old St. Paul High Bridge, spanning the Mississippi River, is dimly seen at the right, while the tall buildings of St. Paul form a background frieze partially obscured by the dense foliage of the summertime trees. A few lights, suggested by quick dabs to the canvas, show that the city is still alive and awake in spite of the darkness and gloom. The painting hints at the artist's intimate knowledge of his surroundings, whose forms are as familiar to him in the dark as they would be in the clear light of day. Moreover there is a spontaneity of expression, a feeling of the immediate experience, that is vividly captured at the precise moment it is seen by the artist. In this respect, too, the painting belongs squarely within the Impressionist tradition.

Allie's death was briefly noted in the *St. Paul Pioneer Press* of September 26, 1953, with the observation that the artist had lived in St. Paul for thirty years. Neither the artist nor his family after his death sought the publicity that, in a more metropolitan area with art exhibitions in the public mind and memory, might well have been accorded.

NOTES

1. *St. Paul Pioneer Press*, September 26, 1953, p. 5.

GERTRUDE BARNES
1865–1926?

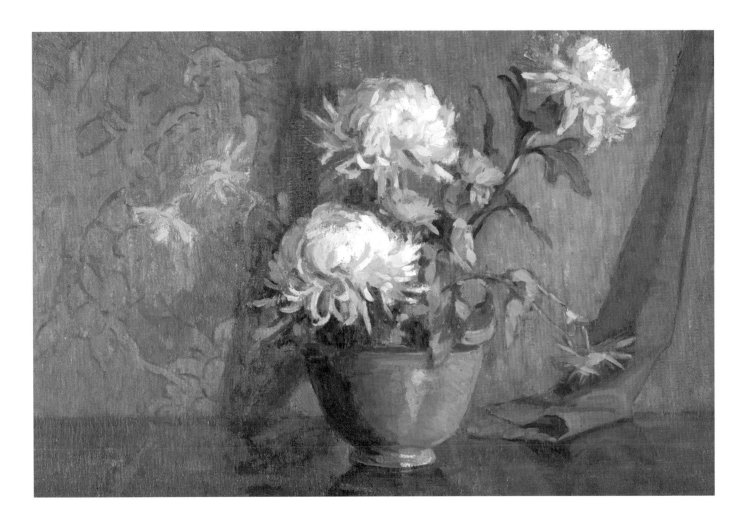

Still Life with a Purple Bowl, ca. 1915
Oil on canvas
20" x 30"
Minnesota Historical Society

GERTRUDE BARNES's richly colored *Still Life with a Purple Bowl* of 1915 is a traditional tabletop arrangement of flowers, draperies, and a vase holding a bouquet, a subject that was regarded as an eminently suitable one for female artists. In many families the workday world outside the home was not considered a safe or desirable place for the "weaker vessel" to venture, but since still life was a theme that could be arranged, studied, and

painted within the safety of the home, it was accepted as an appropriate female occupation. Moreover the prevailing opinion, espoused by many men and some women, held that female competition with males in the same profession was a situation to avoid. Thus still-life arrangements were considered suitable subjects for women artists, with some notable exceptions like Mary Cassatt. Curiously the male artists painting in the Impressionist tradition seemed to accept women artists with a greater degree of equanimity than had been the case in most other periods in the history of art, and quite a few women thrived and developed their art in this welcoming, or at least tolerant, atmosphere.

Barnes's *Still Life with a Purple Bowl* is essentially an Impressionist work, even though the objects do not dissolve in a gauzy atmosphere or seem to shimmer in the picture's light. Still a pigment-laden brush is loosely applied to the canvas in true Impressionist fashion to depict the peonies in the bowl and the few orange and yellow blooms that contrast with them. The peonies shade from pink to purple, and in the background, a dark blue drape, decorated with green parrots and purple flowers, echoes the tones of the flowers and vase, all of which are reflected in the highly polished tabletop.

Barnes's still-life paintings, especially those with oriental draperies, were much admired, and one of her paintings, *Chrysanthemums with Old Chinese Hangings*, was displayed at the Art Institute of Chicago in December 1923. But Barnes was not exclusively a still-life painter. She also produced landscapes and many portraits, some of which were done in miniature.

The artist was born Gertrude Jameson in Tyngsboro, Massachusetts, on October 23, 1865. She studied art at the Cowles School in Boston with Dennis Bunker and Charles H. Woodbury and at the Boston Museum of Fine Arts. Later she enrolled briefly at the Art Students League in New York. After she moved to Minneapolis in 1883, she studied painting at the Minneapolis School of Art under the school's first director, Douglas Volk. She persevered with her painting even after her marriage to Minneapolis businessman Henry A. Barnes, unlike many contemporary women artists who abandoned their careers when they married. Indeed she continued exhibiting her work at Minnesota art exhibitions, winning prizes at the first Minnesota State Art Exhibition that was held in St. Cloud

Gertrude Jameson Barnes, April 30, 1918
photograph by Lee Brothers
Minnesota Historical Society

in 1904 and at the St. Paul Institute in 1916. Her *Still Life with a Purple Bowl* also won a prize in 1915 and was described by a critic as being "most academic but lacking nothing of the modern demands [for] rich color. It also has a curious atmospheric effect. Air seems almost a tangible thing in this picture."[1]

Barnes was an active participant in local arts organizations. She was a charter member of the Artists League of Minneapolis and a supporter of the Handicraft Guild of Minneapolis, a center of the Arts and Crafts movement in America. The Handicraft Guild, which flourished between 1904 and 1918, was founded, led, and mostly staffed by women, many of whom had established careers as painters, sculptors, and art educators. For them, the Arts and Crafts movement provided a means of bypassing the traditional gendering of "fine art" as a male sphere and "craft" as a female one. Throughout the United States, the movement extolled handcrafted work as an antidote to the frequently shoddy products manufactured by nineteenth-century factories. In Minneapolis the Handicraft Guild not only answered a public need for art educators and formal craft training but also provided guild members with studio and workshop space and opportunities for the exhibition and sale of their work. The guild was housed at 89 South Tenth Street in a new facility largely funded by a local philanthropist.

After the 1920s there is little information about Gertrude Barnes. It is not known where or when she died.

NOTES

1. *The Minnesotan* 1, no. 3 (September 1915): 16.

NICHOLAS RICHARD BREWER
1857–1949

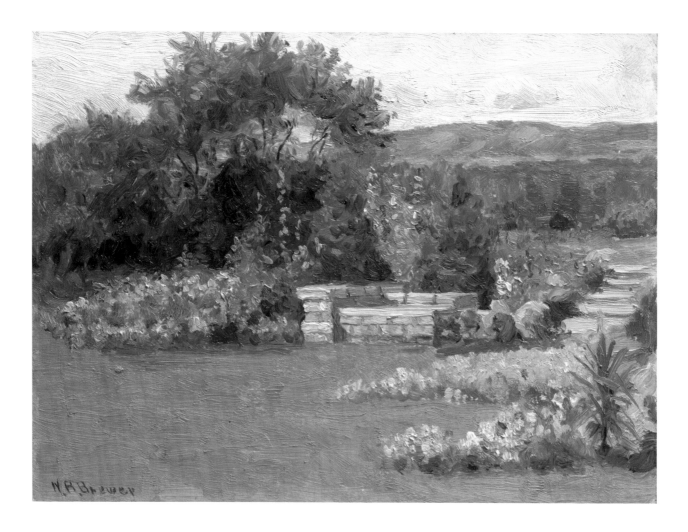

Garden in Winona, 1920
Oil on masonite
9″ x 12″
Private Collection

AMONG MINNESOTA PAINTERS of the late nineteenth and early twentieth centuries, Nicholas Brewer achieved the most national recognition even though in the 1990s he is hardly known outside the state. Like many of his contemporaries, he initially painted in a Barbizon mood, which was characterized by a devotion to the natural landscape, muted tonalities, and an inherent conviction that nature represented the ultimate good. Yet he became

attracted to the Impressionist style with its ability to seize the moment in the out-of-doors and with its high color palette, as his small, undated painting of a *Garden in Winona* clearly suggests.

Nicholas Richard Brewer was born on June 11, 1857, to a pioneering family in High Forest, Olmsted County, Minnesota. By the age of sixteen, he was painting pictures of the landscape in the primitive manner of one entirely self-taught. His efforts attracted some local attention, and in a show of family support, as Brewer recalled in his autobiography, *Trails of a Paintbrush*, his father gave him a load of forty bushels of wheat that he and his brother hauled to the nearby town of Rochester.[1] With the thirty-four dollars earned from the sale, Nicholas boarded a train bound for St. Paul, determined to learn how to paint like a professional artist. He had his first art lessons in St. Paul from Henry J. Koempel, a history and portrait painter from Cincinnati, from whom, as it turned out, Brewer acquired more than instruction in art. He fell in love with Koempel's daughter, Rose Mary, and the two were married in St. Paul in 1879. Shortly after their marriage, the young couple moved to New York City where Brewer furthered his art studies under the well-known American Barbizon painters Charles Noel Flagg and Dwight William Tryon, whose soft colors and crepuscular views of nature dominated the landscape art of the time.

After a few years the Brewers returned to St. Paul where the artist established a studio as well as a permanent home. He traveled widely, however, and particularly liked to visit his good friend, Alexis Jean Fournier, who was the art director of the Arts and Crafts colony known as the Roycroft Community in East Aurora, New York. During these visits, the two artists frequently set out together to paint the peaceful hills and quiet streams of upper New York state.[2]

Brewer by now was painting more than landscapes.

Indeed his reputation as a painter of portraits was gaining increasing national attention, and during the 1910s, 1920s, and 1930s he received a number of portrait commissions from influential patrons. These included well-known statesmen, such as the musician Ignace Paderewski, and the governors and legislators of many midwestern states. He even twice painted the leaders of the land, first President Grover Cleveland and, in 1934, President Franklin Roosevelt. Brewer's portraits reveal a keenly observant eye and an ability to probe the very personality of the sitter. In his autobiography he wrote that in a portrait there must be "an expression of the artist—his conception and description of the character of the subject. If there is that, it is a creative thing and a real work of art."[3]

Brewer's first love remained landscape painting, and he returned to it whenever he could. A particularly successful example in this genre, and one that is completely Impressionistic in its bright, clear light and loosely brushed-in color, is the *Garden in Winona*. The painting depicts the garden at Rockledge, a house that was a Minnesota landmark until it was razed in 1987. Rockledge had been built in 1912 by George W. Maher for Ernest L. King, a southern Minnesota industrialist who was head of the Watkins Medical Products Company in Winona and president of the Winona National Savings Bank. The house that Maher built was an impressive one, following the new, low, prairie style architecture of Frank Lloyd Wright. It was erected on the west side of the Mississippi River, between the river and the steep, rocky bluffs towering above it, and it afforded commanding views of the river. Its garden, beneath the bluffs, was a fitting adornment for the house; like the house itself, it incorporated the natural setting into the general design.

Brewer painted the garden at Rockledge during the height of its summertime bloom. Wild coral lilies had grown there even before the house was built, and the gar-

den attempted to preserve the natural beauty of the site with a cultivated enhancement of it. One sees a band of darker hills in the background, bathed in a blue haze that seems to echo the blues and greens of the garden. The hills create an upper frame for the garden and provide an intermediate step between earth and sky. Separate groups of stone steps lead up the hillside, originally probably forming a series of terraces. These are half hidden by the whites, reds, pinks, and blues of the many flowering plants in full and glorious bloom, all swiftly and loosely applied to the canvas with a thickly laden brush. Like so many French and American Impressionists, Brewer had chosen as his subject not a wild and unkempt view of nature but nature tamed in a tranquil setting fit for contemplation and relaxation. The high color palette vividly suggests the sunny warmth of a summer day under a clear and cloudless sky. The scene has been captured in a fleeting and transient moment in an ideal time when nature smiles at man's creation and invites the observer or the visitor to enjoy its flowering beauty.

At the complete opposite of the seasonal spectrum is Brewer's *Winter Scene, Minnesota, Train in a Snowy Landscape* of about 1920. Here, the harsh, cold climate of the Upper Midwest is graphically shown as a train, seen at some distance, rushes through the frozen landscape. A trailing plume of steam from its engine mingles with the lowering clouds above. A moment in time is instantly captured, although the frosty chill it suggests will not immediately change. The vast, white expanse of snow-covered landscape is actually made up of a number of different colors, dominated by the cold blues and violets of the long Minnesota winter. Even the pale yellow glow of the sun as it lights the frigid landscape seems to emphasize the cold of the winter day. No better examples of the contrasting extremes of Minnesota's climate exist than in these two pictures. Moreover whereas the *Garden in Winona* reflects a settled community in which nature has been domesticated by man, the *Winter Scene, Minnesota,* with its train rushing through the bleak and frozen landscape, suggests instead the advance of civilization into a wild, untamed wilderness.

Brewer died in St. Paul on February 15, 1949. He left an outstanding legacy. Three of his sons, Adrian, Edward, and Rubin, attempted to follow in their father's footsteps and chose careers in art. Those footsteps were hard to fill, however, and although they were competent painters, they lacked that special touch that separates competence from greatness. Unfortunately, like so many of the artists of his day, Brewer painted against the mainstream of his time. He was not an innovator, which the twentieth century particularly admires. Although he achieved much success in his own lifetime, only a few collectors and dealers appreciate his work at this time.

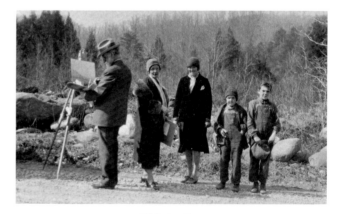

Nicholas Brewer
"We take our lunches with us on trips like this."
Minnesota Historical Society

NOTES

1. Nicholas Brewer, *Trails of a Paintbrush* (Boston: Christopher Publishing House, 1939), 53.

2. Rena Neumann Coen, *In the Mainstream: The Art of Alexis Jean Fournier* (St. Cloud, Minn.: North Star Press, 1985), 53.

3. Brewer, *Trails of a Paintbrush*, 286.

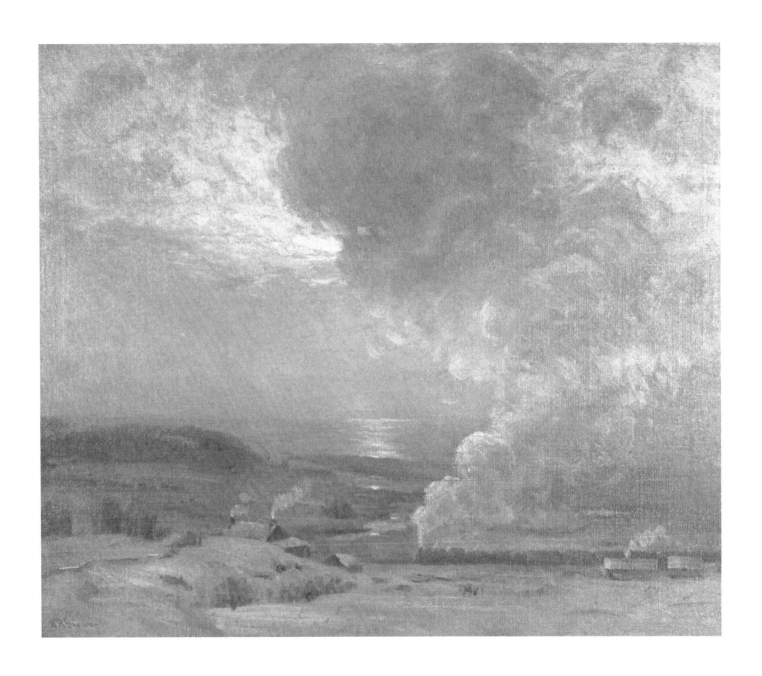

Winter Scene, ca. 1920
Oil on canvas
25 1/2″ x 30″
Collection Minnesota Museum of American Art
Museum Purchase

SAMUEL CHATWOOD BURTON
(1881–1947)

*F*OR THIRTY-ONE YEARS Samuel Chatwood Burton was a familiar figure on the University of Minnesota campus. As the head of the studio arts department and professor of fine arts and architecture, he successfully promoted the arts in the Twin Cities and inspired two generations of art students, either as practitioners of art themselves or as educated observers and patrons.

Chatwood Burton was born on February 18, 1881, in Haslingden, near Manchester, England. He began studying art in Blackburn and, on a scholarship won in competition, spent three years in Paris, mostly at the Académie Julian under the well-known academic painter Paul Laurens. He later studied at the Royal Academy in London under the lesser-known artist Edward Lanteri.[1]

In 1912 Chatwood Burton emigrated to the United States. He received his first academic appointment at the University of Illinois, where he stayed for two years. In 1915 he joined the faculty of the University of Minnesota. For the rest of his life, he taught painting, sculpture, and etching and lectured on the history of art and architecture at the university. Meanwhile he continued to produce his own work, examples of which are in the collections of the major art museums of the United States and England.

Chatwood Burton was enchanted by Spain. In 1921 on his first trip there, he traveled throughout the country, visiting the usual tourist attractions as well as small towns and villages tucked away in remote regions. On that trip he almost died when he was caught in a hotel fire in Segovia. Trapped in his room on the fourth floor with no possibility of escape, he watched with more than casual interest as the peasants carried water in jugs to douse the flames, which fortunately they succeeded in extinguishing. Subsequently Burton visited Morocco, and he also toured France, Belgium, Switzerland, and Italy. The main result of the trip was a series of etchings depicting the towns and architectural landmarks of Spain. The art journal, *International Studio*, observed that "the fine feeling for form and mass that characterizes this artist's work" was evident in his published etchings.[2] On a subsequent trip to Spain in 1937–1938, Chatwood Burton wrote and illustrated *Spain Poised*, containing another series of highly praised, prize-winning etchings.[3]

For an artist with such a highly developed feeling for line as is necessary for an etcher, it is surprising to discover that Chatwood Burton was also a fine painter, and an Impressionist one at that. Impressionism, by its very definition, requires a painterly approach to art in which color, and even the manipulation of paint itself, takes precedence over the strong line and precisely defined form required of the successful etcher. Yet Chatwood Burton's painting *Christmas Eve on the Bohemian Flats* of 1919 demonstrates just such an Impressionist orientation. In true Impressionist fashion, the forms in the picture are blurred, in this case by the effect of falling snow, and the houses, which are huddled together as though for protection from the cold, seem almost to dissolve in the frigid atmosphere.

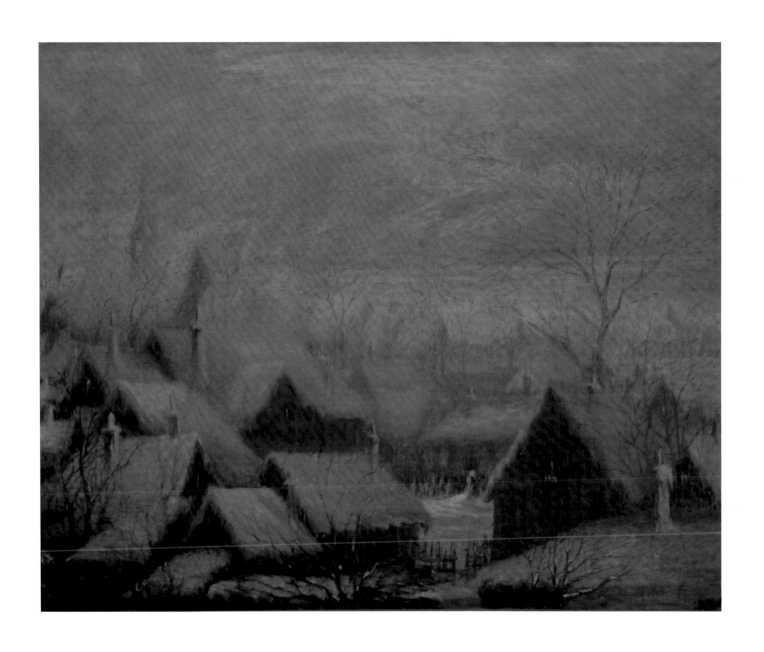

Christmas Eve on the Bohemian Flats, 1919
Oil
40″ x 50″
Minnesota Historical Society

The essence of the cold is enhanced by the dark blue-green of the nighttime scene, relieved here and there by a few quick dabs of orange. With only three or four rapid brush strokes, the artist portrays a small group of people in the distance, illuminated in the bright light of an open doorway. We cannot see them clearly enough to determine who they are or what they are doing, but given the season, they may well be Christmas carolers enlivening the cold winter night with their singing.

The Bohemian Flats was an almost isolated village within the boundaries of the city of Minneapolis. Many of its houses were quickly built shanties, some covered with tarpaper roofs and most of them without foundations or indoor plumbing. The houses, jumbled together on three crowded streets, occupied an area of flat land between the west side bluffs and the Mississippi River, directly across the river from the University of Minnesota. A wooden stair-case of seventy-nine steps led down to the flats from the Washington Avenue Bridge. The area had been settled in the 1860s by Danish immigrants and later by Bohemians, who gave the flats its name. Eventually Irish immigrants joined them. Through all its changes in ethnic population, the Bohemian Flats retained its Old World flavor. As a contrast to Chatwood Burton's cold winter scene, Alexander Grinager's sun-drenched one of *Boys Bathing* (p. 51) offers a portrayal of a group of youngsters from the flats about to dip into the cool river water on a blazing hot summer day.

In February 1947, Chatwood Burton was hospitalized for a nervous breakdown. He was discharged from the hospital on February 24, still seriously depressed. On March 4, in his southeast Minneapolis home, he took his own life. He was sixty-six years old.

NOTES

1. *St. Paul Dispatch*, March 4, 1947, p. 5.
2. *University of Minnesota Techno-Log* 3, no. 1 (November 1922).
3. *University of Minnesota Techno-Log* 4, no. 2 (December 1923).

ELISABETH AUGUSTA CHANT
1865–1947

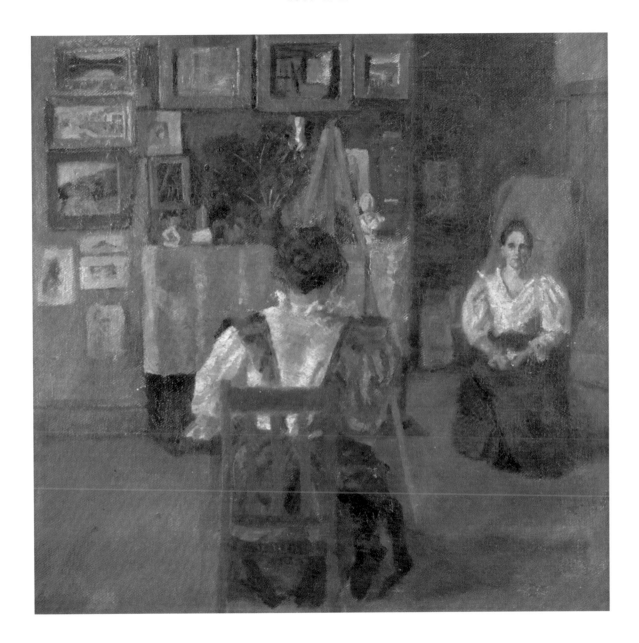

Minnesota Studio, ca. 1900
Oil on canvas
13¹/₄″ x 14″
St. John's Museum of Art, Wilmington, North Carolina
Gift of Henry J. MacMillan

THE MOST MYSTERIOUS and enigmatic personality in the history of Minnesota art is possibly Elisabeth Augusta Chant. Although she claimed to have been born at sea in a vessel captained by her father, James Chant of the East Indian Merchant Marine, she was actually born in Yeovil in Somersetshire, England, in 1865. A year after her birth, Captain Chant had his ship, the *Cora Linn*, outfitted with a cabin so his family could accompany him, and some of Elisabeth's younger siblings were born at sea. As a child, Elisabeth knew at first hand the ports of England, India, and the Far East and later liked to say that she had "sailed the seven seas before she was seven."[1] She had a passion for travel, both to her native England and to more exotic locales.

Captain Chant emigrated to Hawley, Minnesota, in 1873 with a group of other Yeovil families, lured by the promise of free land and job opportunities with the Northern Pacific Railroad. But pioneer life was hard in Hawley, and after seven years of struggle and the death of his wife, Captain Chant moved to Minneapolis where he opened a meat market.

From an early age, Elisabeth desired to pursue a career in the arts, but she acquiesced in her stepmother's insistence that nursing was a more appropriate occupation for a young woman. She enrolled in the nursing program at Northwestern Hospital for Women and Children in Minneapolis, graduating in 1886. During the Spanish-American War, she was the first nurse sent to the United States Army camps in the southeast by the Minneapolis branch of the American Red Cross. She rose to the position of chief nurse,[2] but in 1899 Elisabeth returned to Minneapolis, more determined than ever to become an artist.

She had previously managed to study painting at the Minneapolis School of Art with Douglas Volk, the school's first director, and with Burt Harwood. At the school, then located at 719 Nicollet Avenue, she met Margarethe Heisser. The two became close friends and shared a room, which they sublet from Alexis Jean Fournier during his frequent absences. In that studio, Elisabeth and Margarethe produced work in various media, including painting, pottery, and decorative work on panels, screens, and furniture. Their studio was also the meeting place of the Minneapolis Arts and Crafts Society in which the two women played an active role. The group was one of the first Arts and Crafts societies in the country and an important midwestern outpost. Based on William Morris's example in England, the American movement attempted to counteract the shoddy workmanship of manufactured goods with carefully handcrafted and aesthetically appealing objects for everyday use.

The American Arts and Crafts movement, although it quickly gained momentum and an influential following, was still regarded with some suspicion by outsiders who thought it harbored eccentrics rowing against the tide of industrialization. Chant, in her personal beliefs and even in her appearance, undoubtedly contributed to this view. She lived partly in a secret world in which she was a cosmic being to whom the goddess Athena had given the name Hebe. She also communicated nightly with spirits from another world, helping them through the process of reincarnation. In her dress, too, she refused to abide by the current fashions and designed her own costumes. These were usually of two pieces, a skirt and a tunic, frequently cut with long, butterfly sleeves, which gave her a vaguely medieval appearance. Contrary to the taste of the time, she favored bright colors, and since she was a skilled needlewoman, she incorporated Japanese embroidery and brocade into her costumes. She seems to have ignored the

arresting, some thought shocking, effect her appearance had on the public.

While residing at the studio, Chant painted *Minnesota Studio* about 1900. The theme was a traditional one in the history of art, popularized by William Merritt Chase but going back well into the seventeenth century in Europe. Chant painted a sitter facing the viewer and posing for the portraitist, very likely Elisabeth Chant herself, who is sitting at her easel with her back to us.[3]

Beyond the seated artist, a number of small landscapes hanging on the far wall beckon the viewer into the interior space of the picture. They provide compositional balance to the painting and especially to the figure who confronts the painter, as well as the viewer, with a calm and monumental serenity. The painter herself faces her easel whose inverted V shape is, in turn, balanced by the ruffled straps of her green pinafore. The painting is executed in broad, clearly visible brush strokes. The bright

Elisabeth Augusta Chant
photograph courtesy of Sherron R. Biddle

palette of colors in the background landscapes provide a typical Impressionist dimension to the painting, adding light and color to the interior darkness of the room. Chant, in her later work, moved away from her early Impressionism, embracing instead the deliberate manipulation of planes and the patterned flatness of such modernist movements as cubism.

In 1911 Chant moved from Minneapolis to Springfield, Massachusetts, where she stayed for six years, working as a muralist and designer. In 1917 at the instigation of her family, she was arrested and committed against her will to a mental hospital in Rochester, Minnesota. Upon her release three years later, she embarked on extensive travels through the Far East and the Philippines. On her return to the United States in 1922, she settled in Wilmington, North Carolina, claiming that she could no longer tolerate the harsh northern winters. She probably also wished to distance herself from her siblings who believed that she was mentally ill. She remained in Wilmington for the rest of her life, lecturing on art, teaching art classes, arranging exhibitions, and attempting to establish an artists' colony there in the spirit of the Handicraft Guild in Minneapolis. She was also active in the formation of the short-lived Wilmington Museum of Art. On September 21, 1947, Elisabeth Chant died in Wilmington at the age of eighty-two. Throughout her life, she rebelled against conventional ideas and believed to the end that one gains a moral, even mystical, strength by incorporating art in one's everyday life.

NOTES

1. Anne G. Brennan, *Elisabeth Augusta Chant* (Wilmington, N.C.: St. John's Museum of Art, 1993), 7.

2. Harriet S. Schmidt and Henry J. MacMillan, *Elisabeth Augusta Chant* (Wilmington, N.C.: St. John's Museum of Art, 1972), unpaginated introduction.

3. Jan Vermeer in *The Artist in His Studio* (1665–1670) used an unseen mirror, as Chant did, to portray himself from the back.

EDWIN M. DAWES
1872–1945

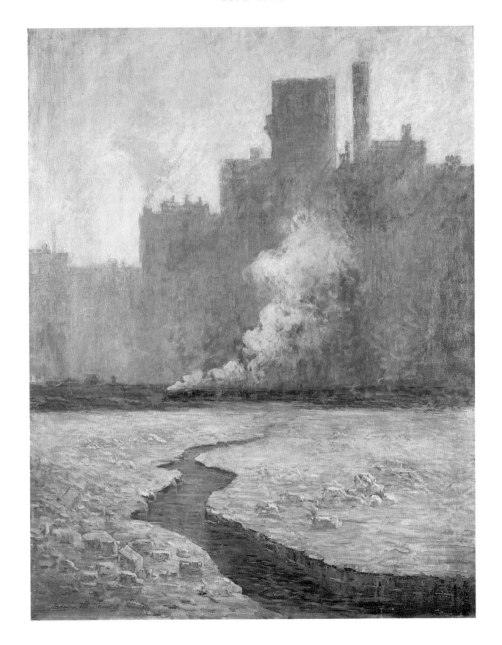

The Channel to the Mills. 1913
Oil on canvas
51″ x 39 1/2″
Minneapolis Institute of Arts

MOST OF THE IMPRESSIONIST MASTERS of France painted the rural scene or, on occasion, the tree-lined boulevards and parks of Paris. Their preference for country landscapes and even their studies of nature in the city were typical of most American Impressionists as well, for the study of light in nature was the main preoccupation of all the Impressionists. There are, however, a few outstanding Impressionist views of the industrialization of America, and one of these is *The Channel to the Mills*, painted in 1913 by Edwin Dawes. It depicts an open-water channel curving through the icy Mississippi River to the flour mills of Minneapolis, a major source of that city's wealth and importance. The simplified forms of the mills, seen as a single block of geometric shapes rising in the hazy distance, are half hidden by a vaporous plume of steam from a passing train on the far shore. Indeed although the mills seem to dissolve in the shimmer of smoke and steam, they nevertheless maintain a monumentality that romanticizes the promise of progress and prosperity associated with the increasing industrialization of the Twin Cities of Minneapolis and St. Paul. The mills themselves are ill defined in the cloudy atmosphere, their warm colors of pink and violet contrasting with the cold greens of the frozen river.

Edwin M. Dawes was born in Boone, Iowa, on April 2, 1872. Although he studied briefly under William L. Lathrop in New Hope, Pennsylvania, he was mostly a self-taught artist. By 1892 he was earning a living as a sign painter and residing in Minneapolis. The city directories list him as a painter from 1892 through 1909 and, in a professional step up, as artist thereafter. Success as an artist was a long time in coming, however. In 1913 three Dawes paintings, including *The Channel to the Mills*, which won a gold medal and a special diploma for "general accomplishment in local themes," were exhibited at the ninth annual exhibition of the Minnesota State Art Society. In 1913, 1914, and 1915 (even though the artist may not have been in Minnesota in the last two years), more pieces of his work won prizes in local competitions.

At some time in 1913 Dawes left Minneapolis in spite of the measure of local success he was finally achieving.[1] He seems subsequently to have divided his time between California and Nevada where he had gold and silver mining interests. But he did not completely sever his connections with Minnesota. He had made enough of an impression in Minneapolis to have a loyal following there, and in 1923 a show of forty landscapes Dawes had painted in California, Nevada, and Montana, as well as Minnesota, were displayed in the city. Indeed this exhibition may have been arranged "without the knowledge of the artist," according to a review.[2] Whether it was shown with Dawes's knowledge or not, the writer gave the exhibition whole-hearted praise.

Dawes, like so many of his contemporaries, was not influenced by the modernist trends already apparent in the decades before his death. He died in obscurity and mostly forgotten in Los Angeles on March 24, 1945. He left a legacy of numerous landscapes, mostly of a conservative nature, of woods and meadows and of the deserts and mountains of the West. Many, although not all of them, are painted with a quick dab of a visible brush stroke and a few with the broken-color technique that is the signature of the Impressionists. In *The Channel to the Mills*, quite arguably his finest work, Dawes used that technique to depict a shimmering cityscape of the nation's flour milling capital on the Mississippi River.

NOTES

1. *Minneapolis Tribune*, November 12, 1913, p. 15.
2. *Minneapolis Journal*, October 14, 1923, p. 4.

AXEL DAVID ERICSON
1869–1946

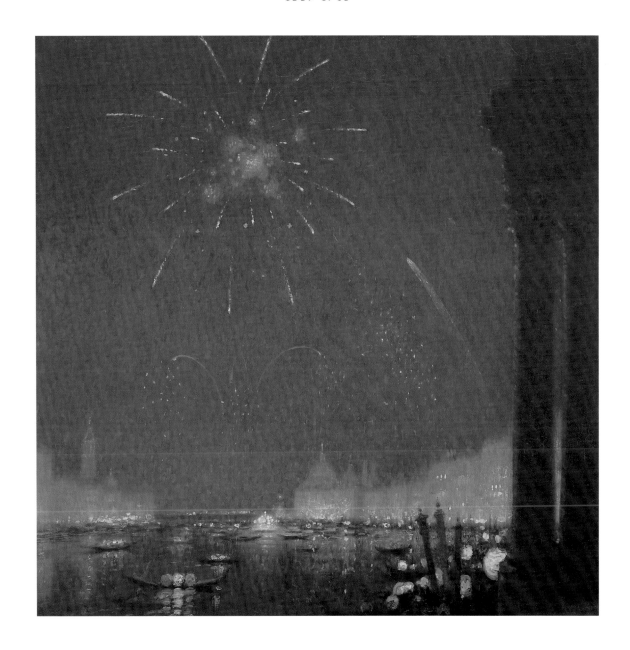

Carnival in Venice, undated
Oil on canvas
32″ x 32″
Private Collection

AXEL DAVID ERICSON is probably the most important artist to have worked and lived in Duluth, Minnesota, in the early years of the twentieth century. Born in 1869 in Motala on the Göta Canal in Osterfotland, Sweden, he was the son of a blacksmith's helper who, seeking a better life for his family, immigrated to the United States in 1872. A year later he sent for his family waiting in Sweden, and they settled in Duluth. Life was hard for the transplanted family, and the elder Ericson was frequently absent for long stretches of time, searching for seasonal work on farms as far away as the Dakotas. David's older brother, Alfred, died at the age of fifteen, and another brother, Enoch, died as a young man. David himself suffered a crippling infection at the age of eleven and had to undergo the amputation of his right foot. But in spite of these hardships, David was determined to become an artist. His choice of a career could hardly have inspired confidence in the poverty-stricken Ericson family.

Fortunately David's artistic ability, apparent even when he was a young child, moved two Duluth residents, Emily Sargent (later Mrs. F. W. Paine) and C. F. Johnson, to give the boy some artist's materials and lessons. At the age of sixteen, he entered a large canvas, *Salting the Sheep*, in the art competition of the Minnesota State Fair and won a gold medal for it. Thus encouraged, he strengthened his determination to pursue his artistic education and to prove to his family that he could, indeed, earn an adequate income as an artist.

In 1887 Ericson left Duluth for New York City where he enrolled at the Art Students League under the direction of William Merritt Chase, a well-known American Impressionist, and also under Henry Cox and William Mowbray, two much more academic painters. He cultivated some important friendships in New York, among them John H.

Twachtman, an advocate of "plein air" painting and an influential Impressionist, whose portrait Ericson painted.

With funds he acquired from the sale of his paintings and also from illustrating magazines and designing jewelry for Tiffany and Company, Ericson embarked in 1890 on the first of his many trips to Europe. He studied briefly in the Paris studio of James Abbott McNeill Whistler, although Whistler's influence on Ericson did not manifest itself until later. In 1902 after further travels in Belgium and Italy, Ericson returned to Minnesota. A year later he married Susan Barnard of Duluth. Soon thereafter the young couple moved to New York where their only son, David Barnard Ericson, was born in 1904. Ericson continued his European travels throughout his life, returning periodically to Duluth, which he always considered his home. Teaching assignments in various locations helped to supplement Ericson's income from the sale of his paintings. In 1908–1909 he taught at the School of Art in Buffalo, New York, where he may have encountered the melancholy, sometimes mysterious work of Alfred P. Ryder, another early influence on Ericson. In 1901, on another European trip, he painted the Coast of Brittany, one of the first paintings by Ericson to show the impact of Whistler in its tone and mood. Whereas he was affected by Whistler's paintings, Ericson seems to have ignored the modernist works of Picasso and Braque, who were the reigning avant-garde artists in Paris during the Ericsons' sojourn there about 1911. Forced by the outbreak of World War I to return to the United States, the Ericson family moved to the artists' colony in Provincetown on Cape Cod, Massachusetts, hoping to escape New York City's dominance in American painting. In Provincetown, Ericson continued to paint and teach, and with the exception of periodic visits to Duluth, the family lived there until 1924.

In that year, with the funds realized from a six-panel mural commission for the Hibbing, Minnesota, high school, the Ericsons returned to Europe. By this time the artist's style began to show, to a small degree, the impact of the bright palette and flattened forms of Henri Matisse, the only modernist beside Whistler to have exerted some influence on Ericson. For the most part the Duluth artist clung to a stubborn independence throughout his life. During the 1920s Ericson began to gain recognition, exhibiting his work in art shows in Duluth and Detroit.

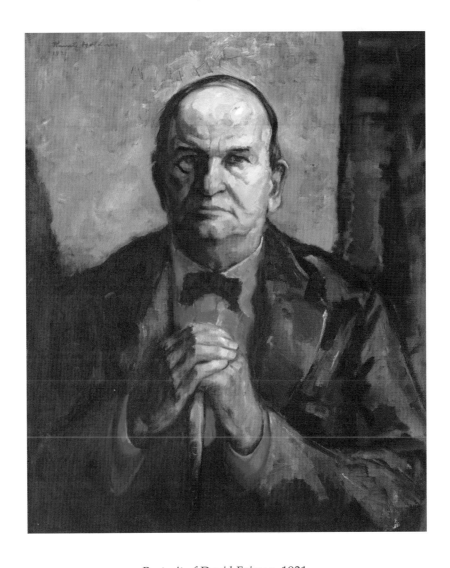

Portrait of David Ericson, 1931
by Knute Heldner
Oil on canvas
32 1/2″ x 25 1/2″
Tweed Museum of Art, University of Minnesota Duluth
Gift of Mrs. E. L. Tuohy

Early in 1930, the Ericsons visited Venice, where the artist painted a number of views of that ancient city. Perhaps the most unusual of these is the very Whistlerian *Carnival in Venice*, painted about 1930–1931. The choice of a night scene demonstrates the hold that Whistler exerted on Ericson, especially Whistler's many nocturnes for which he is justly famous. In Ericson's painting, the quick dabs of paint suggest the exploding rockets bursting in brilliant color over the Grand Canal. They cast the churches on the shore, including the Church of Santa Maria della Salute (which Ericson painted in a number of separate canvases), in a bright, reflected light. The large brush strokes so loosely applied to the canvas demonstrate as well the lessons Ericson had learned from both the French and American Impressionists. The painting reveals the artist himself as a master Impressionist, in control both of his inner vision and of the technical ability necessary to transcribe the immediacy of the experience to the viewer. Ericson considered his Venetian pictures the highlight of his career. In May 1933, in a letter to Dr. Arthur Collins (of Duluth), the artist wrote: "Today we took a look at my Venetian pictures; there are ten rather large ones and a number of smaller ones. I have developed a personal style in these so that they are the most elegant in color and tonal qualities that I have ever done. I have worked," he continued, "for the romance of the old dream city on the sea."[1]

With the outbreak of World War II, the Ericsons returned to the United States, settling once more in Provincetown. Susan Ericson, who had been in poor health for some time, died two years later in 1941. Lonely and depressed after his wife's death, Ericson returned to Duluth, where he continued to paint and teach. He died on December 16, 1946, of injuries received in an automobile accident. After his death his work was stored in Duluth, unseen and unnoticed until William Boyce, then director of the Tweed Museum of Art at the University of Minnesota-Duluth, organized a major retrospective exhibition in 1963. Like many provincial artists of his day, he remained outside the mainstream of both European and American art and suffered a neglect and lack of significant patronage that he did not deserve.

NOTES

1. William G. Boyce, *David Ericson* (Duluth: University of Minnesota at Duluth, 1963).

ALEXIS JEAN FOURNIER
1865–1948

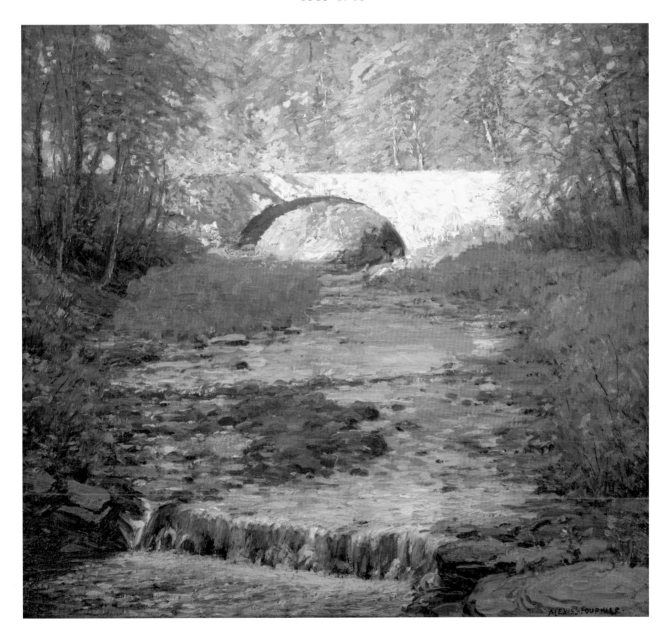

South Bend Bridge, Autumn, ca. 1920
Oil on wood
34" x 44"
First Source Bank, South Bend, Indiana

CALLED "THE LAST AMERICAN BARBIZON", Alexis Jean Fournier painted through much of his life in the Barbizon tradition, which preceded Impressionism in France. The Barbizon artists were among the first to celebrate the out-of-doors in its various moods and seasons, confronting nature directly rather than remembering it and embellishing it later in their studios. The woods near the town of Fontainebleau and the meadows and farms nearby were the subjects of these artists, many of whom lived in the little village of Barbizon. Fournier so much admired the work of these artists, which he had seen on his many trips to France, that one of his major projects was a series of paintings depicting the homes and haunts of the Barbizon painters. He even wrote a book with that title to commemorate his artistic mentors.[1]

Fournier was born a generation after the Barbizon artists, and he eventually came under the influence of the Impressionist masters, who were more his contemporaries. He was even personally acquainted with the great Impressionist painter, Claude Monet. Indeed some of Fournier's latest and finest paintings are completely Impressionist in tone and mood.

Alexis Jean Fournier was born in St. Paul, Minnesota, on the anniversary of the nation's independence, July 4, 1865, to parents who had emigrated from French Canada. He spent some of his early years in Milwaukee, Wisconsin, where he attended a parochial school and carved wooden crucifixes for the school's church altar. By 1879, however, he was back in Minnesota, in Minneapolis where he was earning a living painting signs and stage scenery but devoting all his spare time to painting the outdoor scene. In this he was largely self-taught, although he studied briefly with Douglas Volk in 1886. Volk was a Boston artist who arrived in Minneapolis that year to assume the director-

ship of the newly established Minneapolis School of Art (later the Minneapolis College of Art and Design). Even though Fournier never enrolled in the school, he took private lessons from Volk.

In 1887 Fournier married Emma Fricke who bore him a daughter and a son. At about this time he gave up his sign and stage painting to concentrate entirely on landscape painting. He began to attract important local patrons, among whom was St. Paul railroad and lumber baron James Jerome Hill. In 1893 this group of benefactors helped to subsidize Fournier's first trip to France. The artist enrolled at the Académie Julian in Paris where he studied with Jean Paul Laurens and Benjamin Constant, two well-known French academic painters who taught a whole generation of American students. While still a student at the Académie Julian, Fournier received the signal honor of having one of his paintings, *Spring Morning near Minnehaha Creek*, accepted for exhibition in the Paris Salon of 1894. Fournier returned to Minneapolis in 1895, but he made several trips back to France, the last time in 1913.

Fournier never entirely gave up his Minneapolis connection, exhibiting through the years at the Beard Gallery on Nicollet Avenue. But on June 1, 1903, he moved to East Aurora, New York, at the invitation of Elbert Hubbard, the founder and guiding spirit of the Roycroft Arts and Crafts community there. The two had been acquainted for some time, and when Hubbard asked Fournier to be the permanent art director of the Roycroft community, the artist happily accepted. His duties were more in the nature of artist-in-residence than as a full-time administrator. Hubbard, who was a rather flamboyant person, admired Fournier's work as well as his dark good looks and frequently unconventional dress. "You ought to be able to paint," he told Fournier, "you look the part."[2]

Shortly after Hubbard and his wife died in 1915 on the torpedoed steamship *Lusitania*, Fournier, having lost his good friend and chief patron in the Roycroft community, began to associate with a group of Indiana artists who were establishing a school of Impressionistic landscape painting in Brown County, Indiana. He remained identified with the Roycrofters, but his relationship with the Hoosier Impressionists grew closer in 1922 when the widowed Fournier married Cora May Ball, the widow of Clarence Ball, an Indiana painter of landscape and still life. Fournier's turn toward Impressionism is evident in his view of a *South Bend Bridge in Autumn*, undated but probably painted in the 1920s or 1930s. Fournier's own keen observation of nature and his dedicated pursuit of the effects of light and atmosphere on the outdoor scene fostered his transformation from Barbizon moodiness to

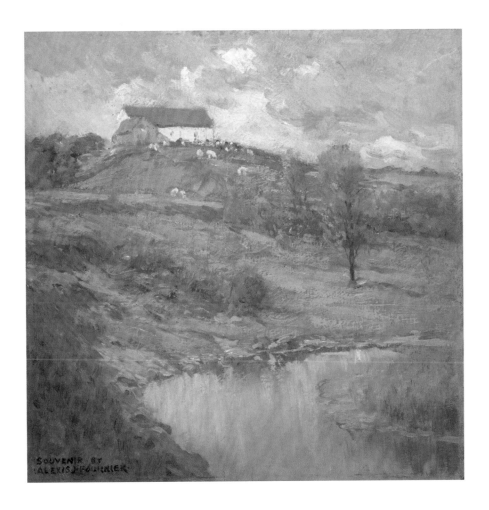

Souvenir (French Country Scene), undated
Oil on panel
12" x 12"
Michael Wodnick

43

Impressionist exuberance using the Impressionists' broken color technique and broad brush strokes in the many sketches upon which his more carefully finished studio pictures were based. There is a spontaneity in this painting, however, that is not always present in the artist's earlier work, and a transient moment in time is vividly suggested through the ephemeral effects of color and light.

Another late painting that is typically Impressionist in terms of color and light is a small picture he titled *Souvenir*. Perhaps painted in France or else drawing on memories of the French rural scene that he so loved, it depicts a group of farm buildings perched on the top of a hill. In spite of the modest size of the picture, it conveys a monumental impression of the scene through the stable, pyramidal structure of the hill and the perfect balance of the buildings at the left and the budding trees at the right. The work offers graphic testimony to the artist's adherence to the Impressionists' ideas and to his lifelong fondness for the outdoor scene.

Twice widowed, Fournier married again at the age of seventy-nine. His last wife was Coral Lawrence, a widow who worked as a writer for the many Hubbard publications in East Aurora. She survived her husband when Fournier died on January 20, 1948, after a fall on the icy sidewalk near his home in the Roycroft community, to which he had returned after his foray into Indiana. His death in the out-of-doors, perhaps from a stroke that preceded his fall, was somehow fitting for this lover of nature, for even in the wintry northern climate of western New York state, the fresh outdoor air was preferable to Alexis Jean Fournier to the indoor world of domestic warmth and comfort.

Alexis Jean Fournier, ca. 1930s
Minnesota Historical Society

NOTES

1. Alexis Jean Fournier, *The Homes of the Men of 1830* (New York: William Schaus, 1910).
2. Rena Neumann Coen, *In the Mainstream: The Art of Alexis Jean Fournier* (St. Cloud, Minn.: North Star Press, 1985), 54.

ANTON GÁG
1859–1908

NTON GÁG'S WORK is a blending of the Old World and the New. His works range from historical panoramas to still lifes, portraits, landscapes, and eventually to photography. He was a jack-of-all-trades in art, an approach that characterized much immigrant endeavor in a pioneer American society. He painted rococo child angels bearing garlands for the short-lived art academy he attempted to establish in New Ulm, Minnesota, as well as a number of unpretentious Impressionist landscapes.

New Ulm had been settled by German, Bohemian, and Swiss immigrants, and Gág himself, who had been born in Neustadt, Bohemia, in 1859, came to the United States as a teenager with his immigrant parents in 1873. Gág lived in New Ulm, married, and eventually raised a family, which he supported, however meagerly, by painting signs, decorating churches, and even painting houses. On Sundays he would retire to his attic studio to produce "real" art and to indulge in the one cigar he allowed himself each week. As a young man, Gág had studied briefly at the art schools of Chicago and Milwaukee, financed by his life-long friend and patron, New Ulm brewer August Schell. Throughout his life, however, he nourished a forlorn and unfulfilled hope of some day returning to Europe to study painting at one of its art academies. Meanwhile he continued to decorate churches and paint houses, and having learned to use the camera, he opened New Ulm's first commercial photography studio about 1892.[1]

In the same year, Gág painted his best-known work, a panorama incorporating eleven panels depicting the battle of New Ulm in the Dakota War of 1862. In this dark chapter of Minnesota history, the desperate and starving Dakota led by Little Crow retaliated against the whites because of unfulfilled promises of food and annuities, which had been guaranteed by treaties. Painted as a continuous narrative, the panorama vividly recalls the battles with the Dakota and hints at the attitude of the white settlers who evicted the Indians from their ancestral lands. The early history of the Gág panorama is not known, but it was discovered in 1955 in a barn near Poughkeepsie, New York, water stained and in poor condition. The Minnesota Historical Society purchased it and kept it in storage, awaiting funds to conserve and restore it to such condition that it may be exhibited as the rare example of panorama painting in America that it is.

In a much more cheerful as well as straightforward vein, Gág painted a number of landscapes depicting the town of New Ulm and the farms and countryside around it. One of these is the *New Ulm Scene, Cow Standing in the River* painted about 1890. Gág had always shown a willingness to experiment with the styles he felt best fit the new landscapes and different spaces of frontier America. Although his roots were in the decorative rococo tradition of eighteenth-century Europe and his artistic career evolved in almost total isolation from current developments in Europe, he nevertheless was aware of, and receptive to, such new painting styles as Impressionism. The red cow, standing half submerged in the stream, the foliage of the trees, indeed, all the elements of the scene are

captured with a few rapid strokes of the artist's brush. The play of light and shadow on the river and its banks is subtly but truthfully evoked. In the background, beyond a tree that has fallen untidily on the bank, a modest wooden building is shown. Its humble construction fits well with the casual approach portrayed in the scene. This lack of pretension, the unselfconscious ordinariness of the place, are elements that put it in the same tradition as Impressionism. So is the suggestion of an unstudied, spontaneous moment in time, caught between ephemeral changes in light and atmospheric conditions. Indeed, Gág's picture of a common, unposed country scene in its honesty and sympathetic feeling for an undistinguished bit of the out-of-doors not only relates it to the Impressionists' approach to landscape painting but also proves that art can, and does, flourish even in pioneer communities far from the acknowledged centers of artistic production.

Anton Gág's daughter, Wanda Gág, was a well-known writer of children's books, which she illustrated with captivating lithographs. Today her fame as an original illustrator is greater than her father's reputation as a painter, but he was the one who inspired her, recognized her talent, and encouraged her to pursue an artist's career. Shortly before his death from lung disease in New Ulm in 1908, he told his daughter, "What I couldn't do, you must do." She more than fulfilled her father's dreams.

NOTES

1. Brown County Historical Society, New Ulm, *Impressions of an Immigrant*, exhibition catalog, June 2–August 2, 1986.

Anton Gág and wife Elisabeth
Minnesota Historical Society

New Ulm Scene: Cow Standing in River, ca. 1890
Oil on cardboard
4" x 6"
Minnesota Historical Society

HERBJØRN GAUSTA
1854–1924

Boy Setting Trap, ca. 1905–1908
Oil on canvas
20 3/4" x 26"
Luther College Fine Arts Collection

THE FARM LANDSCAPE painted about 1901 by the Norwegian-American artist Herbjørn Gausta is a typically Impressionist one. Using the broken color technique of the French Impressionists, in which dabs of pure color and the tangible evidence of their application on the canvas provide a characteristic richness of surface texture, the painting conveys in an almost palpable way the sense of a hot, humid midsummer day in Minnesota. The colors them-

selves suggest the heat, for even the sky, which is reflected in a small pond that is normally a cool, blue color, in this case is tinged with a warm violet, suggesting the slightly hazy heat of the day. The composition is a simple one, with a low horizon creating a narrow band of farm fields. They appear to be baking in the sun, shining down from a sky in which only a few white fluffy clouds interrupt the vast expanse. A modest farmhouse, half hidden behind the tall grasses, seems to absorb into itself the rays of the sun. The artist was clearly familiar with the style of the French Impressionists. He had undoubtedly seen their work on his travels through Europe and also at an exhibition of recent French works that was held in Munich in 1879 when he was studying art there. Like his mentors, Gausta avoided all use of black in this painting, for the Impressionists believed that black implied an absence of light itself, and light—an intense, bright light—is the very essence of the *Farm Landscape.*

Farm Landscape, ca. 1900
Oil on canvas
30" x 36"
Minnesota Historical Society

Herbjørn Gausta was born on the Gaustad family farm in Vestfjorddalen, Telemark, Norway, on June 16, 1854. When he was thirteen years old, his family (they later dropped the final "d" of their name) emigrated to Fillmore County, Minnesota, and settled on a farm near Harmony. Two years later the elder Gausta died, leaving a widow with four daughters and Herbjørn, the only son. The family was left in rather straitened circumstances, a condition that did not improve when Herbjørn entered Luther College in Decorah, Iowa, in 1872 to study in a three-year program to train parochial school teachers. Instead of becoming a teacher, however, upon completion of the course in the fall of 1875, he went to visit his homeland and study art in the city of Christiania. In the summer of 1878 he left to attend the Academy of Art in Munich, Germany. The Academy had already attracted a number of international students, including some Americans, although Gausta seems to have associated with the Norwegian artists there rather than the American ones. The Munich Academy espoused a style of broad-stroked painting, in some ways similar to Impressionism but with a darker background in which brown predominated.

In 1888 after thirteen years of travel and study abroad devoted increasingly to landscape painting, Gausta returned to the United States and settled in Minneapolis, his home for the rest of his life. He did not give up his travels, however, for in 1894 and 1899 he returned to Europe, visiting Germany and France as well as Norway. It is probably during these later trips that the influence of French Impressionism was reinforced in his work.[1]

Gausta's early style is more linear and also more narrative, occasionally illustrating a moral lesson. The *Lay Preacher*, based on a sketch in one of the artist's pocket sketchbooks and painted in 1884, is a case in point. With a fine ability to draw the rough and unidealized characters in the composition, he painted the group surrounding the preacher with a knowing and expressive line. But even this picture reveals a certain familiarity with the work of the French Impressionist painter Degas, especially in its off-center composition and oblique view into the picture plane. In a 1908 painting, *Boy Setting Trap*, the artist employed an even looser brush technique than in his earlier ones in which the influence of the Munich style was still evident. *Boy Setting Trap* also has a low vantage point, in this case entirely dismissing the horizon line, which is frequently characteristic of French Impressionism. Like that style, too, it pictures a child subject in the sunny out-of-doors. By the beginning of the twentieth century, Gausta had thoroughly assimilated their teaching and their artistry.

Gausta died in Minneapolis on May 22, 1924, alone and unsung. He had never married, and there was no close family to mourn his passing. Although his obituary was carried in the Norwegian-American press, his death went otherwise unnoticed. For one thing, Gausta had never painted in the abstract, modernist style that became the mainstream of artistic endeavor in the years before his death. Moreover in his later years, he lost something of the vitality of his earlier work, and much of it became rather routine. In the two Impressionist paintings illustrated here, however, he revealed an impressive artistic creativity that establishes his importance.

NOTES

1. Marion J. Nelson, *Herbjørn Gausta, Norwegian-American Painter*, Studies in Scandinavian-American Interrelations 3 (Oslo: Universitetsforlaget, 1971).

ALEXANDER GRINAGER
1865–1949

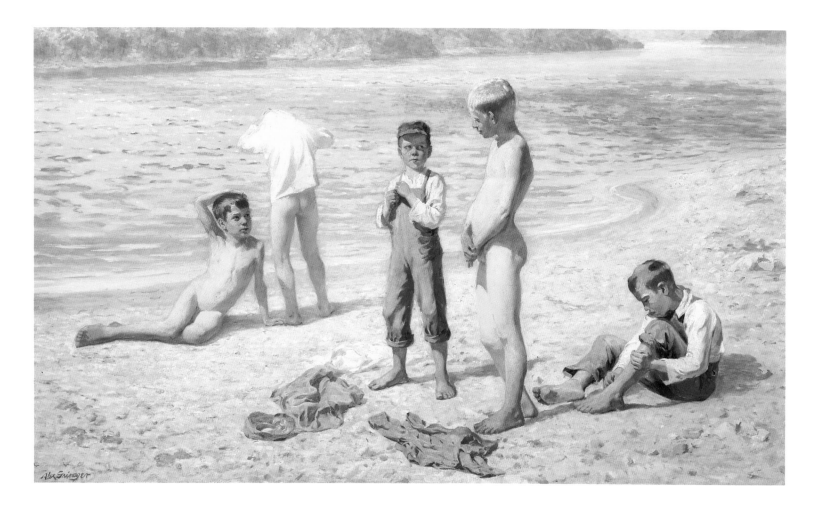

Boys Bathing, 1894
Oil on canvas
34″ x 59″
Minneapolis Institute of Arts

O NE OF THE FINEST figure studies in the history of American art is *Boys Bathing*, painted in 1894 by a little-known Minnesota artist, Alexander Grinager. The picture depicts a popular subject in late-nineteenth-century art, an informal study of the male nude, the best-known example of which is *The Old Swimming Hole* by Thomas Eakins. In Grinager's painting a group of boys is caught in a blaze of brilliant light on the bank of the Mississippi River. The boys

were poor, immigrant children from a shanty town that existed under the west end of the old Washington Avenue Bridge in a section known as the Bohemian Flats. Beyond the flats, near the river, there was an open space that served as a welcome playground for the neighborhood children.

Boys Bathing shows a group of boys in various stages of undress, with the typical awkwardness of adolescent children. The scene is so drenched in the warm light of the sun that it belongs to what one art historian has termed the "glare esthetic." The glare esthetic, frequently associated with Impressionism, offered an alternative way of looking at light in order to heighten its pictorial impact. Often, as in Grinager's picture, the effect of light is intensified by the elimination of tonal contrasts. The boys themselves seem to be captured in the casual manner of one who is a part of the scene. The high-toned palette of brilliant light caught at a specific and fleeting moment in time is also typically Impressionistic. There is, however, one significant difference between *Boys Bathing* and most Impressionistic painting. Although the study of light in nature is certainly characteristic of Impressionism, the portrayal of five ragamuffin boys of poor families is not. The Impressionists were, by and large, painters of the leisure activities of the middle class and of each other and, with few exceptions, avoided portraying those who were down and out. Grinager's picture, therefore, is interesting for its realist subject matter in an Impressionist technique.

Grinager was born on January 26, 1865, to Norwegian immigrant parents in Albert Lea, Minnesota. He began his art training in Minneapolis with the Danish-born artist Peter Gui Clausen, a painter of church frescoes, portraits, landscapes, and stage designs. Under Clausen's tutelage, Grinager painted stage scenery in Minneapolis, an artistic genre to which he sometimes returned in later life. When he felt that Clausen had no more to teach him, Grinager left Minneapolis to study briefly under C. W.

Krupp in Philadelphia, after which, in 1887, he embarked on his first trip abroad. He studied for four years at the Royal Academy of Fine Arts in Copenhagen, where he came under the influence of the Impressionist "plein air" movement. From there he went to Paris to study for a short time under two well-known academic painters, Benjamin Constant and Paul Laurens.[1] He also traveled in Norway, France, Italy, and Sicily, returning home to Minneapolis in 1894 with a solid academic background and an admiration, as is apparent in that year's *Boys Bathing*, for the color and light of the Impressionists.

Grinager rented a studio in Minneapolis and began exhibiting his work. He also became active in the Minneapolis Artists League, founded by Robert Koehler, the second director of the Minneapolis School of Art. Grinager stayed in Minneapolis only two years, leaving for Ossining in Westchester County, nor far from New York City. That town remained his home for the rest of his life. Somewhere along the way he married Margaret Wade, a painter, designer, and weaver, and the couple eventually had two sons.

Margaret and Alexander Grinager traveled a good deal, especially to Cornwall, where they became members of an artists' colony known as the Kernow Group of Truro, England. At a number of exhibitions by this group in the 1920s, both Grinagers showed Cornish landscapes. Many of the Kernow Group's exhibitions were held in the Regents Park, London, home of Maud Adams, a well-known dancer, who had asked Alexander Grinager to design some stage scenery for her. She subsequently became a good friend of both Grinagers. In the catalog of one of the exhibitions of the Kernow Group held in Maud Adams's home, Margaret Grinager's work was singled out by one critic for special praise as "brightly colored and full of light and air. She has made a skillful adaptation of impressionist methods to suit her modest and accurate work."[2]

Grinager also showed his work in a number of important exhibitions in the United States, including a series of six panels for the Mines and Mining Building at the Century of Progress Exposition in Chicago in 1933–1934. His paintings were also regularly displayed at the prestigious Salmagundi Club from 1908 to 1946. He died in New York on March 8, 1949. *Boys Bathing* was widely exhibited and received a good deal of critical acclaim during Grinager's lifetime. Today it is probably the work for which he is best known. An article in the *St. Paul Pioneer Press* describing his pictures reported that "his canvases fairly radiate sunlight and there is a joyfulness and buoyancy contained in his work which imparts itself to the viewer."[3] *Boys Bathing* proves this point.

NOTES

1. *St. Paul Pioneer Press*, March 9, 1910, p. 12.
2. "Exhibition, West Wind, Regents Park, Maud Adams, Dancer," *Western Morning News and Mercury*, October 15, 1929, clipping in curator's office, Minneapolis Institute of Arts.
3. *St. Paul Pioneer Press*, March 9, 1910, p. 12.

SVEN AUGUST (KNUTE) HELDNER
1877–1952

Marine, North Shore, Lake Superior (Seascape), undated
Oil on canvas
27 1/4″ x 36 3/8″
Tweed Museum of Art, University of Minnesota Duluth
Bequest from estate of Theresa M. Wood

*S*INCE SCANDINAVIANS FORMED a large part of Minnesota's immigrant population in the late nineteenth and early twentieth centuries, it is not surprising that many of the state's artists were Scandinavian. Knute Heldner was one of them. The youngest of seven children, he was born in 1877 in Vederslov in Sveland Province in south-central Sweden. From the age of twelve to fifteen, he was in the Swedish navy, serving in the North Sea. After returning

from duty, he studied drawing briefly at the Karlskrona Technical Institute. But the sea was still in his blood, and at the age of eighteen he went back to sea as a cabin boy on a ship bound for Germany and France. While on this trip, he saw many of the great paintings of Europe and vowed that one day he would be a painter.[1]

At age twenty-three, Heldner immigrated to the United States and eventually settled in Duluth, Minnesota, where many of his countrymen were making their homes. To earn a living, he worked at various jobs that included sheep herding, farming, working as a lumberjack and ore miner, and even cobbling shoes. All his spare time,

April Day (Hillside Birches), 1921
Oil on canvas
34" x 30"
Minnesota Historical Society

however, was spent drawing, carving, and painting, and whenever he could, he taught those arts as well. He studied briefly at the Minneapolis School of Art, and he may have also attended classes at the Art Institute of Chicago and possibly the Art Students League in New York. Heldner waited for twenty years to fulfill his ambition to become a recognized artist, but in 1920 one of his paintings won first prize at the Minnesota State Fair. Part of the prize was a trip, sponsored by the State Fair Art Board, to Washington, D.C., to meet President Warren Harding. His years of struggle to earn a living and also to pay tuition at various art schools seemed finally to be paying off.

In 1923 Heldner married Colette Pope, who had been a student of his in Duluth. She later became a recognized artist in her own right. The couple had a son and daughter. In 1926 they began spending summers in Duluth and wintering in New Orleans, which they had first visited in winter 1923.[2] Interestingly the Heldners were among the first friends of playwright Tennessee Williams, and it was they who introduced Williams to the French Quarter in New Orleans and to the artists' community there. Today both Duluth and New Orleans claim Knute Heldner as their own.

Heldner received three years of art study in Europe in 1929 under the sponsorship of Mrs. Herbert Dancer of

Lake Shore (North Shore), undated
Oil on canvas
12" x 16"
Tweed Museum of Art, University of Minnesota Duluth
Bequest from estate of Theresa M. Wood

Duluth. While in Paris he was awarded the significant honor of exhibiting one of his paintings at the Autumn Salon of 1931. Following his return to Duluth, he was invited to exhibit at the Century of Progress Fine Arts Exhibition in Chicago in 1932.

Heldner's undated painting, *Marine, North Shore, Lake Superior*, is a rare example of a Minnesota seascape. Heldner depicted the waves of the lake, which can be dangerously heavy in the fall, breaking and foaming along its rocky shore. At the same time, the surge of the water's ceaseless movement contrasts with the immobility of the jagged rock masses. One wonders in looking at this picture of Minnesota's north shore how much Heldner had seen of Winslow Homer's many seascapes of the coast of Maine. The transient, essentially Impressionist, character of Heldner's lake scene is reinforced by the swirling eddies of water as the lake rushes upon the land and just as swiftly recedes. Above a high horizon line, a cloud-streaked sky casts a cool and somber tinge on lake and shore, hinting at the long, cold season soon to come when the lake is locked in ice. With bold, sure brush strokes, the artist has captured the ephemeral character of the Lake Superior scene.

A similar feeling for the transience of the ever-changing outdoor scene is depicted in another Heldner painting, *Hillside Birches*, which is even more Impressionistic than his marine picture. The time is early spring, when the stand of birches on a hill above a lake is just about to leaf out. The almost bare branches of the trees generate a delicate lacy pattern against the sky, while the white birch trunks create a configuration of uneven verticals against the foreground hill. We sense, in an immediate way, the chill that is still in the air as late winter changes into early spring in Minnesota. Even the color palette of browns, whites, and pale greens emphasizes the changing season. The movement of the brush is broad and sure, catching in a few well-placed strokes the changing moment of an outdoor scene.

Knute and Colette Heldner were divorced not long before his death on November 6, 1953, but they continued living together, and Colette was with him during his final weeks. A comprehensive retrospective of his life's work was held at the University of Minnesota campus in Duluth in 1981. Today although he is hardly a household name in art, there are some collectors and specialists in American art who admire his work. He was chosen one of twelve outstanding American landscape artists by the American Federation of Art, and his works were selected for several shows at the Art Institute of Chicago. His pictures also hang in several other major galleries and museums, including the Corcoran Gallery and the Smithsonian in Washington, D.C., the National Gallery in Goteborg, Sweden, and the Luxembourg Gallery in Paris. In spite of the vicissitudes that were visited upon him, he amply fulfilled his youthful vow of one day becoming a recognized artist.

NOTES

1. David N. Wiener, "Heldner Painted for Art, Not Money," *Duluth News Tribune*, January 11, 1981, Today's Living sec.
2. Historic New Orleans Collection Newsletter 7, no. 1 (Winter 1989): 10.

ALICE HÜGY
1876–1971

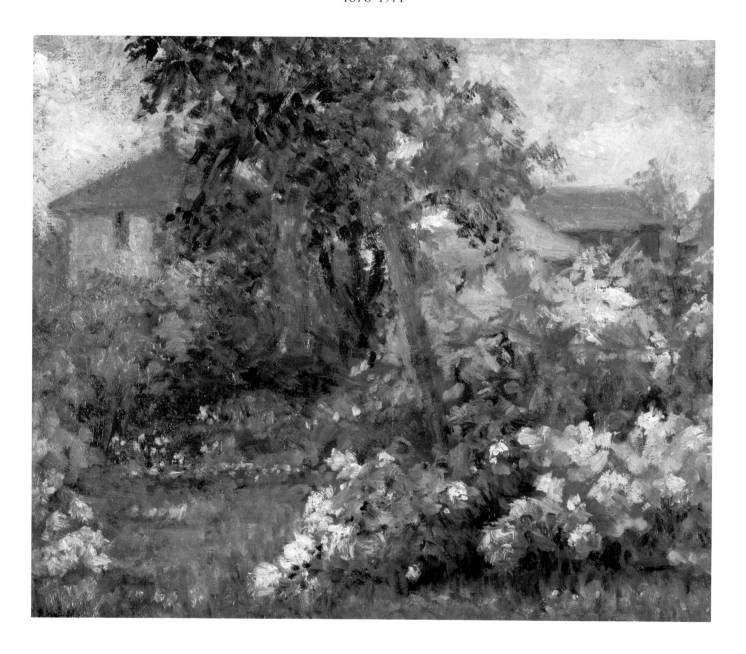

Garden, 1920's
Oil on canvas
16^1/$_8$″ x 20″
Minnesota Historical Society

ALICE HÜGY, who was known as the matriarch of the St. Paul art colony, was born in Solothurn in the German part of Switzerland on January 2, 1876. She was reared in the home of a French uncle, René Vilatte, who provided her earliest criticism and encouragement in art. In 1882 Vilatte brought his family, including six-year-old Alice, to the United States, where he installed them in a house on Cherokee Avenue in St. Paul. Vilatte, who seems to have been a colorful character, operated a butcher shop in St. Paul in the 1880s and 1890s but, according to later reports, spent most of his weekdays in a shanty down near the river, returning to the family home on weekends. He was known for passing much of his time cursing the United States and the Catholic church.[1]

Alice was devoted to art from her earliest days. Although she never graduated from grade school, in 1893 she attended one of St. Paul's early art classes, which was held in the attic of the old Metropolitan Building. She later took additional art training at St. Paul's School of Fine Arts and in New York City, where she stayed for five years. At some time she must have visited Alaska and the Far West, for she painted landscapes of both areas, but most of her life was spent in St. Paul.

Hügy's exhibition career started in 1910 at the Minnesota State Fair. Her pictures were also shown at the Minneapolis Institute of Arts, the Minnesota Art Society, the Watercolor International in Chicago, and the Philadelphia Annual All-American Show. St. Paul knew Hügy as a successful commercial artist, who included among her accounts the William Banning Agency, St. Paul's first such enterprise, Hamm's and Grain Belt Beer, and Minneapolis's New England Furniture Company, whose trademark image of a young and attractive "Priscilla" by Hügy became well known in the Twin Cities and beyond.

Outside of her commercial work, Hügy was known mostly for her still-life paintings, although she painted portraits and landscapes as well. Independent and outspoken, she was not a woman to keep her opinions to herself, and she criticized much of contemporary art for what she considered a phony sentimentality. She maintained that even stilllifes must avoid affectation, for flowers, too, have an individuality that can be captured by an artist sensitive to their infinite diversity.[2] Hügy was also a woman of boundless energy, who established St. Paul's first art gallery and taught for many years in its art school, housed in the old Newton Building on Minnesota Street. During the 1930s Depression, she, like so many of her contemporaries, painted for the Works Progress Administration (WPA).

The Impressionistic painting of a Minnesota garden, which is entitled simply *Garden*, was executed by Hügy around 1925. Its vigorous brushwork is similar to that of the French masters, who originally developed the Impressionist style in the 1860s and 1870s. Using the Impressionists' broad brush strokes, which are clearly visible on the canvas, the artist reveals the very means by which she has constructed the painting. She thereby creates an intensely personal relationship with the viewer, since she has not smoothly polished away the strokes of the brush that indicate her presence in the creative process. Typically, too, the bold strokes seem to flatten the perspective of the painting, drawing our attention to the two-dimensionality of the canvas, almost in a mosaic-like way. They create an overall surface design of bright color that only suggests, rather than precisely delineates, the forms of the flowers, the trees, and even the house in back of the garden. Hügy indulges here in a virtuoso technique that translates, just as Monet and his fellow French Impressionists did, the natural effects of a garden seen in full bloom into

a lavish pattern of texture and color. In its unpretentious subject, its seeming spontaneity, and its eminently painterly style, it is a fine example of Impressionist painting in America.

The love of nature that is so vividly apparent in Hügy's *Garden* reflects a devotion to nature that made her an early environmentalist. Indeed the city of St. Paul honored her late in life for her primary role in preserving Cherokee Park in its natural state at a time when the city leaders were considering the sale of the park to a commercial developer.

In spite of her lack of a formal education, Hügy prided herself on her love for art, nature, music, literature, philosophy, and "humanity." She died in St. Paul on November 24, 1971. Her legacy is summed up in the definition of art that she gave a newspaper interviewer, "which is the response to the beauty and wonder of the world we live in."[3]

NOTES

1. *St. Paul Pioneer Press*, May 1, 1932.
2. *St. Paul Pioneer Press*, March 21, 1926.
3. *St. Paul Pioneer Press*, March 5, 1967.

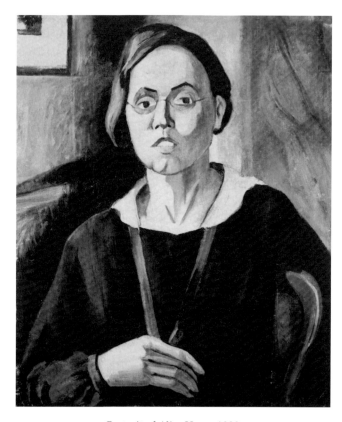

Portrait of Alice Hugy, 1922
by Clara Mairs
Oil on canvas on board
24" x 20"
Minnesota Historical Society

LOUISE KELLY
?–1948

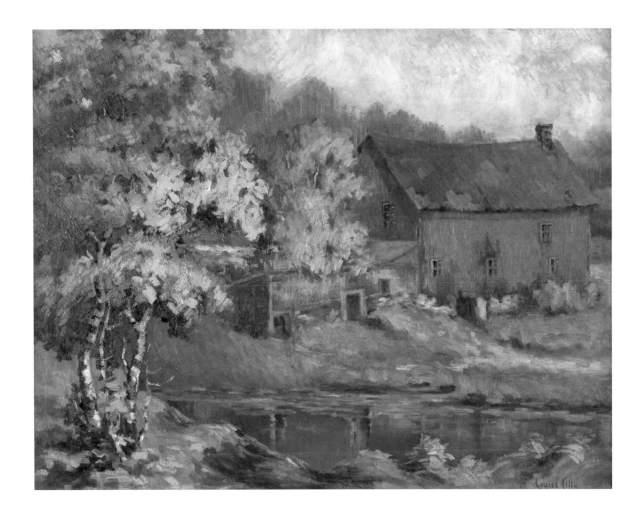

Old Edina Mill, 1923
Oil on canvas
28¹/4″ x 36″
Minnesota Historical Society

*L*OUISE KELLY is one of those women artists who, although possessed of significant artistic talent, have gone quite unrecognized in the history of American art. Born in Waukon, Iowa, the eldest of the five children of John and Dorothy Minart, Louise studied painting at some of the leading art schools of America, including the school of the Art Institute of Chicago and the Pennsylvania Academy of Fine Arts. She also traveled to England, France, Italy, North

Africa, and Mexico and spent several summers at the artists' colony in Provincetown on Cape Cod, Massachusetts. At one point she joined a group of New York artists under the leadership of George Elmer Brown, who gathered first in Paris and then moved to the south of France to the foothills of the Pyrenees to paint. They stayed in an ancient and primitive hotel, whose bad accommodations were matched only by its bad food, but in the six months this trip lasted, she managed to complete twenty-five paintings.[1]

At some unknown date, probably in the late 1910s, Louise married Edward P. Kelly in Austin, Minnesota, where she taught school briefly. The couple then moved to Carrington, North Dakota, and later to Minneapolis where Edward Kelly became a prominent attorney. Louise Kelly was active in a number of arts organizations, including the American Federation of the Arts, which was established in 1909 to circulate art exhibitions throughout the United States. She was also a member of the National Association of Women Artists, organized in 1889. She twice won a prize at exhibitions sponsored by the National League of American Pen Women, first in Chicago in 1933 and then at the Art League Headquarters in Washington, D.C., the latter for a landscape painted in England and entitled *English Countryside*.[2]

Kelly's representation of the *Old Edina Mill*, painted about 1923, amply demonstrates her considerable artistic ability. In a style that is quite Impressionistic, she painted an old red mill in its rather ramshackle later days next to a small, reflecting pond. The scene is portrayed in the light-filled, sunny ambiance of a bright summer day. A loose brush depicts the old mill and the surrounding trees, particularly the clump of silver birches. There is no attempt here at the smooth and polished surface that was the goal of much contemporary academic art. Like other Impressionist paintings, it has a slightly rough texture and an approach that is distinctly casual. The painting, now in the Minnesota Historical Society, was formerly in the possession of Dr. O. F. Schussler, whose father had owned and operated the old Edina mill. It is an unpretentious rendering of an unpretentious scene in what was then the rural environs of Minneapolis.

NOTES

1. *Minneapolis Journal Magazine*, undated clipping, curator's files, Minnesota Historical Society, St. Paul.
2. *Minneapolis Tribune*, April 29, 1934, Books, Art, and Music sec., p. 11.

ROBERT KOEHLER
1850–1917

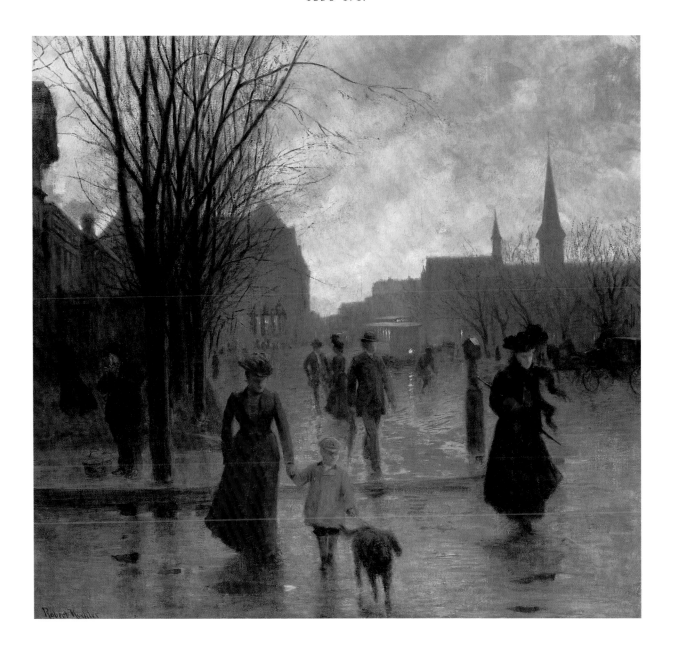

Rainy Evening on Hennepin Avenue, ca. 1910
Oil on canvas
25³/₄″ x 24″
Minneapolis Institute of Arts

\mathcal{R}OBERT KOEHLER was born in Hamburg, Germany, on November 28, 1850, and immigrated to the United States with his parents in 1854. The family settled in Milwaukee where young Koehler first studied under the Wisconsin artists Henry Viandin and Heinrich Roese. Subsequently he worked in lithographic studios in Milwaukee, Pittsburgh, and New York, while at the same time pursuing his art studies at night.[1]

In 1873 Koehler realized a long-cherished dream of studying in Germany at the Munich Art Academy, which was gradually supplanting the Düsseldorf Art Academy as the main attraction for American art students in Germany. In fact his art teacher, Viandin, a native of Bonn, had studied art at the Academy. On his first return trip to the land of his birth, Koehler stayed for two years before returning to the United States. He then enrolled at the National Academy of Design in New York City and became a founding member of the Art Students League. By 1879, however, he was back in Munich, his trip financed by a wealthy New York brewer, and this time he stayed in Munich for thirteen years, making periodic trips to America. In Munich Koehler established his own art school, taught classes, and actively participated in the artistic life of the city. He was elected president of the Munich American Artists Association and in that capacity arranged to show the work of American artists in Munich at several international art exhibitions. This experience was to stand him in good stead when he became the second director, after Douglas Volk, of the Minneapolis School of Art.

Although Koehler's subjects were mostly portraits, at which he was adept, and rather sentimental genre pictures of peasants in their daily life, he also began to paint pictures of a more radical nature. Koehler was the son of a machinist and was familiar with the working-class environment and people. One of these pictures, quite revolutionary for the time, was *The Socialist*, depicting a fiery orator carried away by the passion of his own rhetoric. An even more radical example is *The Strike* of 1886, a rare nineteenth-century portrayal of labor strife.[2] The picture was painted in both Germany and England—in London and Birmingham—where the artist had studied factory smokestacks and the clothes and gestures of the laborers. Koehler considered *The Strike* to be the best painting he had ever done. It was shown widely and received critical acclaim. He brought the painting with him to Minneapolis, where it was purchased by a group of local industrialists, apparently oblivious to its implications, for the Minneapolis Society of Fine Arts. It was subsequently presented to the Minneapolis Public Library, where it was kept in storage for many years. In the early 1970s, it was traced to Minneapolis by a young Marxist historian who purchased the picture and brought it to the attention of American art historians, after which it was again widely exhibited as an early example in art of industrial conflict.

In 1893, a few months after he had returned from Munich and established a brief residence in New York City, Koehler was invited to become the second director of the Minneapolis School of Art (now the Minneapolis College of Art and Design). As in Munich, he soon became a leader of the artistic community of Minneapolis, not only teaching art but also organizing art exhibitions, encouraging art collectors, and founding or helping to form organizations of arts and crafts people, including the Minneapolis Art League, which for many years played an active part in developing the art consciousness of Minneapolis.

Although Koehler was not primarily an Impressionist painter, the movement was known to him through his extensive travels in Europe. Moreover the Munich Art

Academy advocated a manner of painting that was characterized by a looser and more vigorous brush technique than had been prescribed by the older art academy at Düsseldorf where so many earlier American artists had studied. The "Munich style," as it came to be called, emphasized a thick impasto and clearly visible manipulation of the paint itself to suggest the glint of light on a subject, usually seen against a dark background. Whereas the dark background was characteristically "Munich," the painterly style that dramatized ordinary, genre subjects

through a quick and facile handling of pigment and brush was also part of the French Impressionist artistic manner.

While Koehler's themes were frequently indoor ones, he was also aware of the attractions of "plein air" painting. In a review of an exhibition at the Art Institute of Chicago that appeared in the Minneapolis Journal on December 8, 1912, Koehler wrote approvingly, if not quite enthusiastically, "everything is now out of doors with American artists of the day. It is a fad, and a pardonable one, since it certainly cannot hurt anyone to

Robert Koehler
Minnesota Historical Society

spend as much time outdoors as possible. There are some stunning pictures at the show as well as some mighty poor ones."[3] And, in fact, Koehler himself liked to paint out of doors during vacations, mostly at Lake Minnetonka, which was not far from his home in Minneapolis.

Koehler's picture, *A Rainy Evening on Hennepin Avenue* of about 1912, uses the loose brushwork of both French Impressionism and the Munich style to evoke a rainy evening on a Minneapolis downtown street. Like the Impressionists, Koehler avoided a sharp definition of form in favor of a misty blur that recalls the work of James Abbott McNeill Whistler, America's well-known expatriate artist whom Koehler had met in Europe some years before. Prominent in the picture are Koehler's wife, Marie, and their son, Edwin, as well as the family dog. The soft light and subdued colors immediately capture the mood of a damp, early twilight in the city, thus evoking a vivid sense of time and place.

Koehler died suddenly of a heart attack while riding on a streetcar in Minneapolis on April 23, 1917. His obituary emphasized his devotion to the Minneapolis School of Art, which he had guided for so many years, and his tireless work in fostering the arts in the city that he had adopted as his own. As Frederick J. Wulling, dean of pharmacy at the University of Minnesota and a long-time friend, said at the dedication of a bronze portrait plaque of the artist at the Minneapolis School of Art some ten years later, "Mr. Koehler led the strenuous and impecunious life of a high standard pioneer artist. . . . He contributed more than any other . . . to the present art appreciation hereabouts."[4]

In spite of these words of praise and appreciation, Koehler's work was mostly forgotten until the late 1970s when his paintings were "rediscovered" during a broad-based reevaluation of American art and artists and a renewed interest spurred on by the nation's celebration in 1976 of its bicentennial. As curator Thomas O'Sullivan wrote, Koehler's work, as well as that of many of his contemporaries, finally "found an audience that had often eluded them in their lifetime." In fact, "Koehler's advocacy of an open-minded, all-embracing approach to art as a vital part of a lively community . . . offers a lesson and an example of his continuing relevance to our time."[5]

NOTES

1. Peter C. Merrill, "Robert Koehler, German-American Artist in Minneapolis," *Hennepin County History* 47, no. 3 (Summer 1988): 20.

2. Reproduced in Rena Neumann Coen, *Painting and Sculpture in Minnesota, 1820–1914* (Minneapolis: University of Minnesota Press, 1976), Pl. 32. *The Strike* was traced to Minneapolis by Lee Baxandall, who discovered it in a storeroom at the Minneapolis Public Library. He purchased it from the Minneapolis Institute of Arts, had it restored, and subsequently exhibited it widely in the United States and Europe.

3. *Minneapolis Journal*, December 8, 1912.

4. Merrill, "Robert Koehler," 27.

5. Thomas O'Sullivan, "Robert Koehler and Painting in Minnesota," in *Art and Life on the Upper Mississippi, 1890–1915*, Michael Conforti, ed. (Newark: University of Delaware Press, 1994), 111.

ALICE SUMNER LE DUC
1868–1962

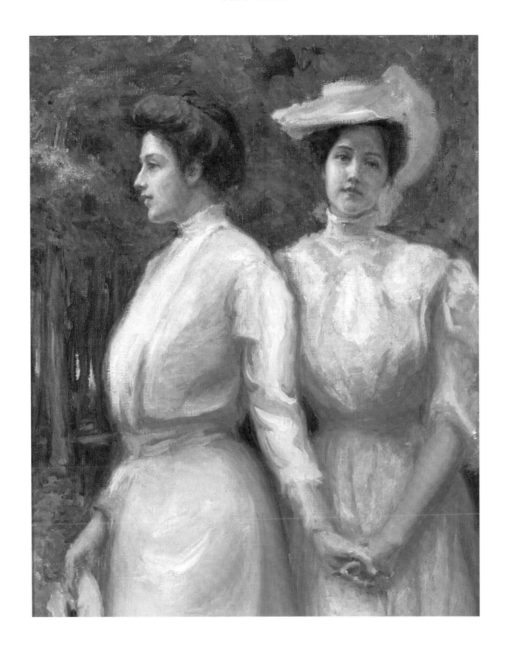

Mabel and Edith Gardner, ca. 1895
Oil on canvas
26 1/2″ x 21 5/8″
Minnesota Historical Society

WHEN ALICE LE DUC PAINTED her two nieces, Mabel Minnie Gardner and Edith Vincent Gardner, sometime in the 1890s, she was indulging in a private hobby of painting simply for her own and her family's enjoyment. She never exhibited her paintings, and perhaps because her training in art was sporadic at best, she may have felt that she was not up to competing with professional artists. Moreover as the daughter of General William Gates Le Duc, she would be jeopardizing her social position by working as a professional artist.

General Le Duc had served with the Army of the Potomac in the Civil War. After the war he returned to Hastings, Minnesota, where he owned a flour mill. His various businesses achieved indifferent financial success, and his family occasionally suffered a genteel poverty. In 1877 Le Duc received an appointment from President Rutherford B. Hayes as United States Commissioner of Agriculture, a post he held for four years. The family thus considered themselves a cut above their neighbors in Hastings whom they thought dull and provincial. Le Duc built a large and stylish house for his family in Hastings. The house still stands as a landmark of the Tuscan Revival style, and it is now owned by the Minnesota Historical Society.

The portrait of the Gardner sisters, General Le Duc's granddaughters, was formerly attributed to Katherine Merrill, a Chicago artist, but a reattribution to Alice Le Duc has been made by art curator Thomas O'Sullivan on the basis of similarities in palette and brushwork to other authenticated paintings by her in the Minnesota Historical Society collection.[1] Furthermore similarities in pose, dress, and composition to photographs of the sisters in the Le Duc papers strengthen the new attribution.[2]

The two young ladies are caught by the artist, posing in their white summer dresses out of doors. Mabel (or Minnie as she was usually called) is probably the one shown in profile, holding a hat in her hand, while it is likely that it is Edith, wearing one of the elaborate millinery confections of the 1890s, who confronts the artist. The white of the ladies' summer dresses is flecked with pink and blue, which is controlled enough to enhance the whiteness of their gowns. Loose brushwork and a broken color technique, as well as a preference for painting the subjects in the sunny out-of-doors, further relates the painting to the Impressionist movement.

Less traditionally Impressionistic and belonging more to what has been called the "glare esthetic" is one of a number of small landscapes painted by Le Duc.[3] Of unknown date and untitled, it shows a shed or lean-to, whose shady interior contrasts strongly with the hot, sunlit field beside it. Slivers of light, penetrating through the thatch of the roof, form a pattern in the dark inside space, and one senses the way the uncovered field soaks up the heat of the sun. Like all Impressionists, Le Duc was concerned with the effect of light on a subject, but instead of dissolving form in a haze of atmosphere, as the earlier Impressionists had done, artists like Alice occasionally adopted the glare esthetic and used light to reinforce form.

Alice Sumner Le Duc was the youngest child of Mary Elizabeth Bronson Le Duc and William Gates Le Duc. She was born in Hastings on February 18, 1868. Although her family recognized and even encouraged her ability in painting and also in writing, except for a brief attendance at an unspecified art school in St. Paul in 1897, she did not formally study art. Neither did she attend college, as her two older sisters had done, and she never married. After her mother's death in 1904, she occasionally traveled with her father on his business trips, helped him with his correspondence, and generally acted as his aide.

Even though women in her social position were not supposed to be employed outside the home, Alice nevertheless joined her sister, Florence, in a business enterprise they started in 1901 called Hastings Needlework. Probably because needlework was considered a purely female occupation, only a few eyebrows were raised by the Le Duc sisters' business. Florence Gray Le Duc had studied painting, wood carving, and metalwork for two years in New York, and it was she who was the driving force behind Hastings Needlework. Alice designed the patterns for the hand-embroidered tablecloths, napkins, mats, and dresser runners created by the business. Her embroidery designs were based on medieval wood carvings of dragons and gargoyles, which she studied from photographs in the Minneapolis Public Library, and also on fanciful birds and flowers "that never bloomed anywhere." Much of the work was executed in linen, often in shades of orange and deep blue. The sisters organized local women to do most of the sewing, and with a business agent they hired in Minneapolis, Hastings Needlework flourished.[4] It had customers in Chicago, including Mrs. Potter Palmer, and in New York and Boston. An

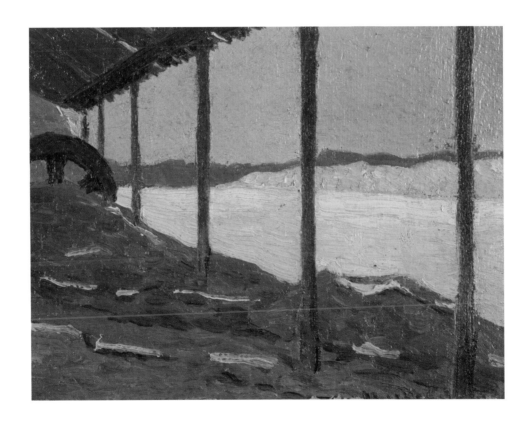

Untitled (View from a shed in the shade), ca. 1905
Oil on canvas
10 1/2″ x 13 3/4″
Minnesota Historical Society

illustrated article on Hastings Needlework describing the business and its products appeared in the October 1903 issue of *House Beautiful,* and examples of the needlework were exhibited in New York and as far away as Paris. The business was successful enough for Alice to buy a house on Humboldt Avenue South in Minneapolis, and the business itself lasted until 1922. The Humboldt Avenue house became a gathering place for the Le Duc family and an escape from the provincialism and lack of cultural amenities that they had always complained of in Hastings. The Hastings house, however, became a summer retreat from the city, and they enjoyed its roominess and the extensive grounds that then surrounded it.

Alice's last years were devoted to work on her family history, which she later gave to the Minnesota Historical Society, and to painting her private pictures. Since she does not seem to have competed in professional art competitions or, aside from the designs for Hastings Needlework, exhibited her work publicly, she was hardly known as an artist in her own time, outside of her family and friends, nor is she better known today. She died, obscurely, in the Humboldt Avenue house on December 27, 1962.

NOTES

1. Curator's files, Minnesota Historical Society.
2. Carole Zelle, *LeDuc-Simmons House, Hastings, Minnesota* (St. Paul: Minnesota Historical Society, 1989).
3. William H. Gerdts, *American Impressionism* (New York: Abbeville Press, 1984), 17–21.
4. William Gates LeDuc and Family Papers, Minnesota Historical Society.

PHILIP LITTLE
1857–1942

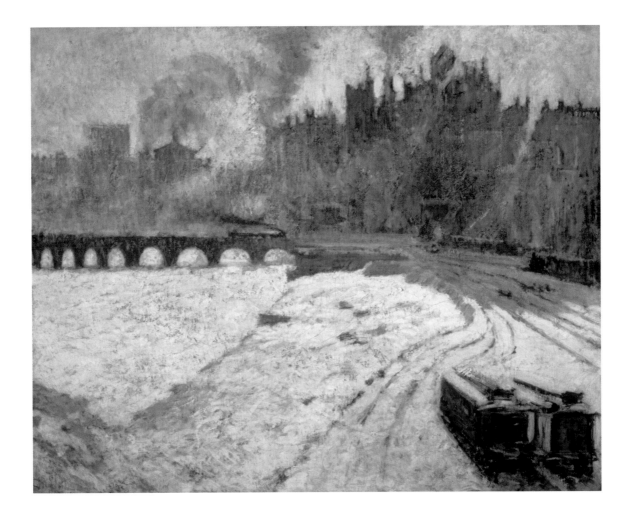

Frozen Mississippi, 1909-1912
Oil on canvas
29″ x 36″
Minnesota Historical Society

PHILIP LITTLE IS generally known as a Massachusetts artist, but possibly through his acquaintance with Robert Koehler, whose portrait he drew, he formed a Minnesota connection, spending some time in the state and showing his work at a number of local exhibitions in the early part of the twentieth century. Born in Swampscott, Massachusetts, on September 6, 1857, he came from a family of substance, for his father was a principal owner of the

Pacific Mills Company of Lawrence, Massachusetts, one of the nation's largest cotton and wool manufacturing companies. Indeed, Little himself worked for at least a year, in 1879, for Pacific Mills.

Art was always Little's first love, however, and after studying from 1875 to 1877 at the Massachusetts Institute of Technology and taking a subsequent tour of the West Indies, he enrolled at the Boston Museum of Fine Arts School of Art. There he met Lucretia Shepard, daughter of a southern plantation owner, whom he married. They had one son, Philip Little, Jr., who later resided in Wayzata, Minnesota. Another classmate at the art school was Frank W. Benson, who became one of the most highly regarded American Impressionist landscape painters and also Little's life-long friend, mentor, and confidant. Many of Benson's surviving letters to Little are full of encouragement for his friend, which was doubtless influential in that Benson himself had become an effective teacher at their old school. In a March 24, 1908, letter to Lucretia Little, for example, Benson remarked that her husband "can now by his own efforts make a name for himself in American landscape painting and that's what the old boys call 'coming home.' "[1]

Over the years, Philip Little won many honors and awards, including the silver medal at the Pan Pacific Exposition in San Francisco in 1915. Although he chose art as a career, he may have thought about the military, for from 1887 to 1901 he was a member of the National Guard, rising from the rank of sergeant to major. During World War I he served in the navy in the camouflage division. Eventually he became the fine arts curator of the Essex Institute and Museum where his tenure lasted from 1916 to 1936. In addition to his curatorial duties, however, he continued to produce his own work.

Little lived briefly in Chicago, staying long enough to become a member of the local Society of Etchers, but after his sojourn in the Middle West, including Minneapolis, he returned to the East, spending his winters in Boston, and later Salem, and his summers on McMahon Island off the coast of Maine. After a long life devoted to the arts as both an artist and as a member and leader of many arts organizations, Little died at his home in Salem on March 31, 1942.

Little's usual subject for his paintings was the New England coast—its ships, its beaches, and its harbor scenes—but occasionally he turned to more industrial themes as he did in the one entitled *Frozen Mississippi*. That the artist was very much an American Impressionist is well evidenced in the loose brushwork and the broken color technique—somewhat modified here—and above all in the inherent interest in light and atmospheric effects on the outdoor scene. Little knew nature in its many moods, and he was able to reproduce it with all the vividness and vitality of the "plein air" painter. *Frozen Mississippi* depicts a snow-covered scene where the frosty air of a winter day makes the flour mills of Minneapolis look as though they were conceived in a fantasy of shimmering light and shadow. Although the river is frozen to shipping until the arrival of the spring thaws, the old stone arch bridge across the Mississippi provides the vital link in the city's continuing prosperity. On the bridge, a locomotive, barely visible behind its cloud of steam, makes its way across the river. Railroad tracks curve into the scene, and beside them two boxcars stand in lonely isolation awaiting future journeys when they will carry the grain and flour of the Middle West. The flour mills themselves, upon which so much of the financial success of the area depended, rise in the distance, adding their smoke to the heavy atmosphere.

The colors in the painting enhance the feeling of a frigid, smoke-filled environment, for shades of blue and purple, as well as various permutations of white, predominate in the picture. The colors reinforce the idea of indus-

trial enterprise on an upward course in spite of the chilling climate, for an occasional bright color note can be seen amid the blues and violets. Indeed the somber hues of gray and black are not even present here, for Little, in line with other Impressionists, shunned black, since it implied the absence of light and therefore of visibility. Even the snow echoes the suggestion of hard work and busy commerce, for it is not the pure white covering of a meadow in the countryside that might well have been chosen as a subject by most of the nature-loving Impressionists. Instead it is the dirty, trampled snow of a railroad yard, where the clean snow of a recent fall does not keep its freshness for long. Painted in a time when the popular imagination had not yet become conscious of the environmental depredation of industrial pollution, the painting voices rather a paean to industrialization, free enterprise, and prosperity.

NOTES

1. Philip Little Papers, Essex-Peabody Institute and Museum, Salem, Mass.

CLARA MAIRS
1878–1963

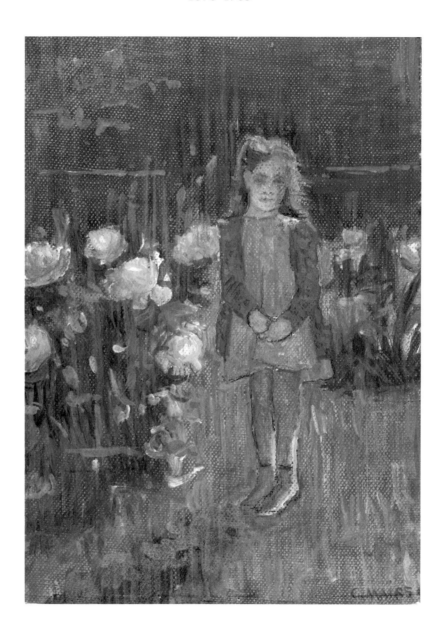

Girl in Garden, c. 1915–1920
Oil on wallpaper on board
8$\frac{1}{8}$″ x 5$\frac{3}{4}$″
Collection Frederick R. Weisman Art Museum
University of Minnesota, Minneapolis

CLARA MAIRS WAS a Minnesotan, born and bred, a descendant of a pioneer family who had established the first grain mill on the Vermillion River in southern Minnesota. She was born in Hastings, Minnesota, on January 5, 1878. Her formal training in art began in 1918 at the St. Paul Institute, and from there she traveled east to continue studying under the landscapist Daniel Garber at the Pennsylvania Academy of Fine Arts in Philadelphia. In 1923 seeking further instruction, like so many contemporary American artists, she went to Paris where she enrolled at the Académie Julian, the Académie Colorossi, and the Académie Montparnasse.[1]

Returning to the United States in 1925, Mairs again took up residence in St. Paul. She also spent much of her time in the region of the Kettle River in Pine County where she depicted the rural landscape and its inhabitants. Her work began to gain some recognition when in 1930 she won first prize for portraiture at the Minnesota State Fair, and in 1931 and 1936 she received awards for her etchings from the Minneapolis Institute of Arts. During the 1930s her work was widely exhibited at such institutions as the San Diego Fine Arts Society, the Dallas Museum of Fine Arts, and the Philadelphia Museum of Art, among others. She also received the honor of having one of her paintings purchased by the United States State Department for inclusion in an exhibition of American art that was circulated in Russia.

Mairs is not generally known as an Impressionist painter because most of her work reveals more modernist trends, such as a feeling for decorative pattern and broad masses and a denial of three-dimensional space.[2] She nevertheless exhibited Impressionist tendencies in at least two works that are undated but probably belong to her early career. One of these, *Girl in Garden*, painted on a piece of wallpaper, was possibly executed between 1915 and 1920. It is a tiny study that closely resembles a much-admired French Impressionist painting, Pierre Auguste Renoir's *Girl with a Watering Can*. The little girl in Mairs's picture stands in a flower garden whose huge blossoms contrast with the diminutive subject of the child. She is clad simply in a blue dress and jacket or sweater and high-buttoned shoes, and she stands rather awkwardly with her hands clasped in front of her. The sunlight streams into the picture, catching the highlights of the child's hair, stockings, and shoes and shining on the large pink flowers whose petals seem to unfold before our eyes. The little girl and her surroundings are caught with a few highly Impressionistic strokes of the brush, which clearly show the presence of the artist through the visible application of the paint to the canvas.

Mairs's companion for much of her life was a fellow St. Paul artist, Clement Haupers. In another picture, entitled *H. Sketching, Minnesota River*, probably dating close to *Girl in Garden*, Mairs painted her friend with a distinct touch of humor, addressing himself to his canvas on the easel in front of him. He is watched by a group of boys lounging about in relaxed poses on a rise behind the artist and, no doubt, wisecracking about the work of art being created before them. Wearing a broad-brimmed hat and holding a pipe in his mouth, Haupers pays no attention to his youthful audience, who offer their various opinions about his work from behind his back. The kids and the natural background of the riverbank are quickly sketched, again with very broad and visible brush strokes, and although Haupers is a bit more precisely portrayed, the boys are very rapidly suggested, with no facial features that would describe them as individuals. The theme of an artist being offered unso-

licited commentary by an untutored entourage is vividly captured in this whimsical painting.

Both Mairs and Haupers were active in the Works Progress Administration (WPA). The WPA was seen as a way of helping artists earn a living when there was little private patronage for the arts and also as a way of encour-

aging a national interest in, and appreciation for, the arts.

In her later years, Mairs began experimenting with glazed ceramics, translating some of her themes into a three-dimensional form. She continued, however, to paint and draw until her death in St. Paul on May 24, 1963.

NOTES

1. *St. Paul Pioneer Press*, May 25, 1963, p. 3. See also Malcolm E. Lein, *Clara* (St. Paul: Minnesota Museum of Art, 1976), and Lein, *Work by Clara Mairs* (St. Paul: St. Paul Gallery and School of Art, 1961).
2. Around 1918 Mairs began to work primarily as a decorative artist, creating gold and silver painted screens and decorative wall hangings.

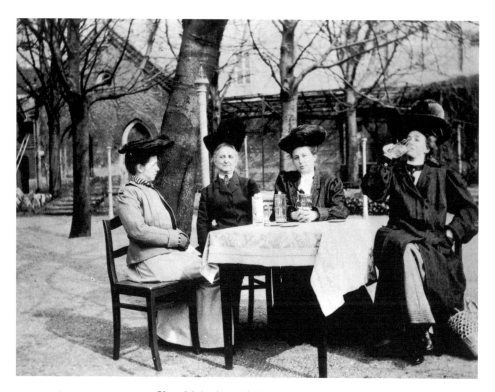

Clara Mairs (on right) in Meissen with
Agnes Mairs, Mrs. Mairs and Helen Mairs, ca. 1905
Minnesota Historical Society

H. Sketching Minnesota River, ca. 1915–1920
Oil on board
18″ x 23⁷/₈″
Collection Frederick R. Weisman Art Museum
University of Minnesota, Minneapolis

HOMER DODGE MARTIN
1836–1897

HOMER DODGE MARTIN is not generally thought of as a Minnesota artist, yet he spent the last years of his life in a quiet farmhouse near St. Paul and worked in a studio he rented above a tailor's shop on St. Paul's Wabasha Street.[1] In his late-adopted city, Martin kept such a low profile that, outside of some friends and art connoisseurs, few knew that the painter who has been called "the first American Impressionist" executed his finest work in St. Paul.[2] That picture is *The Harp of the Winds: A View of the Seine*, painted in 1896 and now one of the most popular pictures in the Metropolitan Museum of Art. It is not, of course, a Minnesota scene at all but a view of rural France, painted from notes and recollections. Martin had lived in France in 1876 and from 1881 to 1886, and memories of the French countryside profoundly influenced his art, remaining with him throughout his life. He visited England, too, where he studied and admired the landscapes of the pre-Impressionist painter, John Constable, and formed a friendship with James Abbott McNeill Whistler.[3] Having just separated from his wife of many years, Martin came to St. Paul in 1893 to live with his son in the belief that Minnesota's clean air and invigorating climate would improve his declining health and failing eyesight.[4]

Martin was born in Albany, New York, on October 28, 1836. He was encouraged by Albany's premier sculptor, Erastus Dow Palmer, and the painter James MacDougal Hart to pursue a career in the arts, so he moved to New York and began exhibiting his work at the National Academy of Design. His formal training in art was quite limited, but he was one of the founders of the Society of American Artists in 1878, and a few years earlier he had been elected a member of the National Academy. He died in St. Paul in 1897 and was buried in a potter's field in Oakland Cemetery. In 1903 his friends had his body removed to a lot they had purchased and marked with a simple, granite stone.

Always an ardent admirer of the outdoor scene, Martin cherished light as both a source of inspiration and the subject of his brush as did the French Impressionists, although unlike several of them, he clung to a definition of form and shape. This devotion is evident in his painting entitled *Forest Interior*, painted shortly after his arrival in St. Paul. It depicts a shady stream darkened by the dense foliage of the summer trees that hide the light from the running waters. Only fitfully does the sun penetrate the heavy vegetation, glinting momentarily on the rocks and the trunks of the birches as they lean over the stream. Almost as though he were describing this painting, the critic, James Thomas Flexner, wrote that Martin viewed nature not as a friend but "rather as an antagonist trying to hide from him an invaluable secret. Martin tried to extract by main force from the most brutal aspects of nature—barren rocks, stunted trees, the dreadful solitude" of nature, "some meaning that would be a release from personal anguish," something "catching happily in a glow of color against somberness, a touching burst of joy. . . . The

Forest Interior, undated
Oil on canvas
$15^1/_2''$ x $7^1/_8''$
Minnesota Historical Society

pictures create a visible world from which sorrow and pain seem completely alien."[5] Martin painted *Forest Interior* when he was almost blind and in poor health. Yet the jewel-like colors, catching like precious emeralds the occasional sparkle of green in the shadowy scene, impart a sense of peace, of repose, and even of hope.

NOTES

1. "Genius in St. Paul Was Unrecognized," *St. Paul Dispatch*, May 8, 1909.
2. James Thomas Flexner, *That Wilder Image: The Painting of America's Native School from Thomas Cole to Winslow Homer* (Boston: Little Brown, 1962), 179.
3. *St. Paul Pioneer Press and Dispatch*, March 6, 1985, p. 9C; St. Paul Pioneer Press, December 13, 1936.
4. Martin's wife, Elizabeth Gilbert Martin, preceded him to St. Paul; see *Homer Dodge Martin, A Reminiscence* (New York: William Macbeth Gallery, 1904).
5. Flexner, *That Wilder Image*, 179.

Homer Dodge Martin
Minnesota Historical Society

MAGNUS NORSTAD
1884–?

City on a Hill, 1917
Oil on canvas
36" x 30"
Minnesota Historical Society

*I*N PAINTING ST. PAUL, Minnesota, as *The City on the Hill*, Magnus Norstad was referring to a conviction prevalent in America's intellectual history that the New World was a new Eden and that its cities represented a new Jerusalem, the American counterpart of the biblical City on a Hill. The idea of a new Jerusalem, reflecting a heavenly city of God, goes back in European thought to St. Augustine who, in the fifth century A.D., had a vision of an eternal city embodying human aspirations toward progress and perfectibility. In eighteenth-century America, Thomas Jefferson and his circle reinterpreted the City of God to mean, specifically, those built in the New World. Here the vice and corruption inherent in the old and tired civilizations of Europe had no hold, and both personal and political morality could be given a fresh start, unencumbered by the sins of the past. Thus in painting *The City on the Hill*, Norstad was not creating a new concept of an imaginary heavenly city but merely applying an old idea to his adopted hometown of St. Paul.

The blue tones that dominate the painting magnify the effects of the frigid winter atmosphere that wraps this northern city for several months of the year in a chilling embrace. On the other hand, dabs of pink and violet are also visible in the picture, providing a rosier, more benign outlook on the long winters and suggesting the milder, warmer seasons that will surely follow. St. Paul is viewed from the vantage point of a snow-covered hill in the foreground. Bare trees on either side frame the city whose tall buildings rise, cathedral-like, in a stable, pyramidal form in the center of the composition. At the base of the hill, long, low-roofed sheds lead our eye to the city on the hill, and the railroad train that puffs a cloud of steam into the wintery air suggests activity, progress, and prosperity for the city that rises above it.

Although Norstad's painting does not dissolve form in a haze of atmosphere quite as much as many Impressionist paintings do, it is still essentially an Impressionist response to a winter scene in the out of doors. The strokes of the artist's brush are broad and sure, and the colors give the view an ephemeral air as though it has just been captured in a transient and fleeting moment in time.

The City on the Hill was shown at the Northwestern Artists' Exhibition at the St. Paul Institute in 1917, where it won a silver medal and a popular vote purchase award. Norstad, who was born in Norway on June 24, 1884, had studied art at the National Academy of Design in New York City. He later became a member of the Artists Guild, established there in 1931. He lived in Minnesota for some time and began showing his work at the Minnesota State Art Exhibition in 1914.[1] Later in his life, however, he settled in the country town of Valhalla, New York, where he lived for the rest of his life.

NOTES

1. Florence N. Levy, ed., *American Art Annual*, vol. 14 (Washington: American Federation of the Arts, 1917).

NATHANIEL POUSETTE-DART
1886–1965

Downtown, ca. 1915
Oil on canvas
13¹/₂″ x 9⁵/₈″
Minnesota Historical Society

AMONG THE IMPRESSIONIST PAINTERS of Minnesota, Nathaniel Pousette-Dart was the one who was the most receptive to the modernist trends that were shaking the art world in the early decades of the twentieth century. Nevertheless his style could be quite Impressionistic in terms of his loose brush-stroke technique and his ability to capture a fleeting moment in time.

Pousette-Dart was born in St. Paul on September 7, 1886. He had a thorough grounding as an aspiring artist at the Art Students League in New York and at the Pennsylvania Academy of Fine Arts in Philadelphia.[1] He was fortunate to count among his teachers some of the best-known artists of his day, including Thomas Anshutz in Philadelphia and Robert Henri and William Merritt Chase in New York. After his schooling in the East, he returned to St. Paul where he exhibited his work at the St. Paul Institute in 1915 and at the Minnesota Art Association in 1913, 1914, and 1916, winning a prize in each of those years.

Pousette-Dart was a man ahead of his time, not only in his acceptance of avant-garde trends in art but also in the social attitudes he shared with his wife. When Nathaniel Pousette and Flora Louise Dart were married on January 16, 1912, he combined his own last name with his wife's to form Pousette-Dart, by which name he was known thereafter. Flora Louise was a woman of strong feminist opinions, for just before her marriage she told a newspaper interviewer that "the modern woman is not to be bound by the same iron chains as the woman of medieval or ancient times. . . . I believe that every young woman of today should insist upon her rights in the marriage vows, just as she is insisting on them in other fields."[2] Her husband, who must have been part of a distinct minority among the men of America in 1912, seems to have agreed.

While pursuing his own career as a painter, Pousette-Dart had to earn a living, which his art alone did not afford. His first job was at the Bureau of Engraving in St. Paul in 1907, but he soon abandoned the Bureau to pursue a secondary career as an art teacher. He was an instructor in the art school of the St. Paul Institute from 1912 to 1918 and a director of the art department at the College of St. Catherine in St. Paul. Later after moving to New York in 1918, he taught briefly at Columbia University and at the New York School for Applied Design for Women. Pousette-Dart was one of the first artists to realize the potential benefit the fine arts could bring to the advertising world. He spent a number of years as a consulting art director for some well-known New York advertising agencies, J. Walter Thompson and Barton, Durstine, and Osborne among them. But he chafed at the time spent away from his easel, and in 1924 he quit the advertising field to devote himself full time and without distraction to painting.

Pousette-Dart was active in a number of arts organizations. He was a founding member and early president of the Art Directors Club in New York and a member of the Westchester Arts and Crafts Guild, the Architecture League, and the New York Federation of Modern Painters and Sculptors. At the same time he was also busy writing and doing editorial work, first as editor of the series, *Distinguished American Artists*. His book about a New York painter and illustrator, *Ernest Haskell, His Life and Work*, was further testimony to his ability as a writer.

Downtown, painted in 1915, depicts a winter day in St. Paul, with the snow falling in big flakes on the buildings and streets. A St. Paul writer could well have been describing this painting when he wrote "Pousette is" his snow pictures. . . . The Minnesota snows, until they fall and lie still, are most busy. Nowhere else in the world does snow come with such joyance; the crisp air has given

individuality to each flake. They do not fall dully; they are never mere flakes of snow falling from sky to earth. There is no hesitation about them, but they do have a lively time of it whether blown about or dancing down."[3] In spite of the inclement weather, however, the painting exudes an air of cheerfulness, as though the artist was convinced that at this time, this was the best of all possible worlds. The dominant colors, especially the brick red of the buildings, reinforce the upbeat quality of the picture's benign view of downtown St. Paul. Here, as in most Impressionist paintings, the artist captures a transient moment in time, although suggesting, through the monumentality of the city's buildings, that St. Paul possesses the essence of urban life. In choosing an urban rather than a rural landscape, Pousette-Dart echoed the interest in city life characteristic of his teacher, Robert Henri, leader of a group of painters called "The Eight" or, more derogatorily, the "Ashcan School," for the fact that the human masses of the cities and, some said, their squalor attracted their brushes. Pousette-Dart's painting differs, of course, in that no people are shown inhabiting the city, but we know they are there. The familiar center of St. Paul is the focus of the composition in a painting that addresses itself to the urban reality of American life in the twentieth century.

Later in his life the artist moved again, this time to the upstate New York town of Valhalla, where a number of artists already lived. He died there on October 17, 1965.

Nathaniel Pousette-Dart
Minnesota Historical Society

NOTES

1. Pousette-Dart also studied abroad for two years on a Cressen Scholarship, which he won in 1909 and 1912.
2. *St. Paul Pioneer Press*, April 16, 1912.
3. Henry A. Castle, *History of St. Paul and Vicinity* (Chicago and New York: Lewis Publishing Co., 1912), 508.

CARL WENDELL RAWSON
1884–1970

Minneapolis from Cedar Lake, ca. 1920
Oil on board
16" x 20"
Minnesota Historical Society

CARL WENDELL RAWSON, "Golfer and Sportsman," is the way this Minnesota artist might well have wished to be remembered, for he loved sports and was an avid outdoorsman his entire life.[1] Born in Van Meter, Iowa, on January 28, 1884, and raised in Des Moines, Rawson earned the money for his first art lessons by working as the secretary of the Des Moines Baseball Club, a member of the Western League. As a teenager, he pitched for a number of

Iowa baseball teams, and later he became a champion amateur golfer. He was also an expert shot, and whenever he could he would go out hunting and fishing. Through his frequent camping expeditions, he knew the woods and waters of Minnesota even before he began to paint them.

Rawson's formal education in art was substantial. He studied first at the Cumming School of Art in Des Moines and later at the Minneapolis School of Art and the National Academy of Design in New York. The artist moved to Minnesota in 1906 to work as a cartoonist for the *Minneapolis Tribune*, and he remained with the newspaper for nine years, sketching thousands of persons for the newspaper.[2] Also in 1906 he married Louella Pattee, a gifted artist in her own right, although she abandoned her own promising career to devote herself to their home and two children.

In 1915 Rawson left the newspaper, determined to be his own boss and to earn his living by painting portraits. Many of these portraits survive, and they include both local dignitaries and national figures. For at least two years, he later claimed, his studio was an operating room in Rochester, Minnesota, where the Mayo brothers were

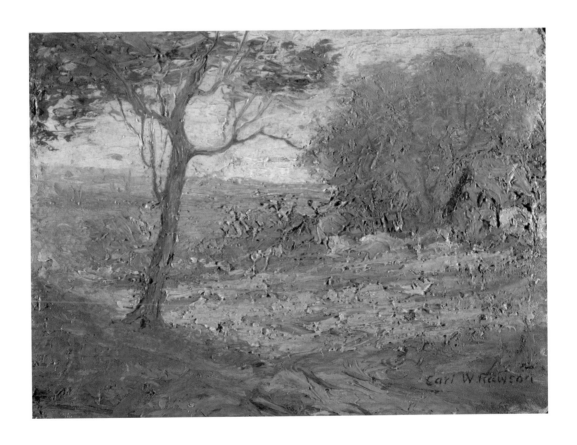

Landscape with Cottage, undated
Oil on panel
6″ x 8″
Private Collection

his subjects. He painted landscapes, too, from the Hudson River in New York to the streams of Arkansas and the hills of east Texas, but he liked best to depict Minnesota, maintaining that Minnesota was as varied in her moods as any place on the face of the earth. Indeed he was of the opinion that the north shore of Lake Superior, which he painted many times and which became his favorite outdoor scene, was much like the coast of Maine, and furthermore he claimed that the color of the lake was more beautiful than the ocean.

In his painting, *Minneapolis from Cedar Lake*, executed around 1920, Rawson used the colors of early autumn to define a place and a moment in time. Cedar Lake, one of Minneapolis's chain of lakes, is seen surrounded by the trees and shrubs of its verdant banks. With the Impressionist painter's broadly brushed style and broken color technique, the artist depicted a Minneapolis spot that, in spite of its title, seems to represent a rural scene far from any urban activity. But the lakes of Minneapolis preserve an intimate contact with nature in a relatively unspoiled setting, and the artist was reflecting the pride of Minneapolis citizens in their natural asset. The painting uses the Impressionist style in the high horizon line so that one seems to be looking down at the scene from a great height rather than on a level with the lake. The casual, unpretentious approach to the view is a further point of reference to the Impressionist style.

Carl Rawson's successful career as a painter enabled him to purchase a substantial house in Minneapolis at 637 Kenwood Parkway, just a short walk from Lake of the Isles. This gave him a daily opportunity to observe with a trained artist's eye the dramatic changes in color and, to a certain extent, the form of the city's lakes as one season gave way to another. From month to month, Minnesota's northern climate provided the artist with different vistas as season followed season. Rawson died in Minneapolis, the city he loved best, on December 4, 1970.

Carl W. Rawson
from *Golfer and Sportsman* magazine, September 1939
Minnesota Historical Society

NOTES

1. Sally Michener, "Carl W. Rawson, Golfer and Sportsman," *Northwest Life,* September 1939, p. 27.
2. Michener, "Rawson," 44.

CLARENCE CLARK ROSENKRANZ
1871–1959

CLARENCE CLARK ROSENKRANZ, an artist of Duluth and St. Paul, Minnesota, was born in Hammondsport in the Finger Lakes district of western New York in 1871. He pursued his art education in New York City under the artists John Ward Stimson, Walter Shirlaw, and William Merritt Chase. Upon completion of his studies he painted and taught art in Buffalo for a number of years. The first exhibitions of his work were at the Buffalo Fine Arts Academy where he won prizes in 1909, 1911, and 1912.

Around 1913 Rosenkranz moved to Minnesota and settled in Duluth where he painted the local outdoor scene in all its dramatic changes of season. To supplement the income from his paintings, he conducted art classes in Duluth. In 1917 he received a commission to paint murals for the North Hibbing Public Library, which were preserved when the building was later razed. This led to another mural commission, in the small town of Buhl, Minnesota. After a few years in Duluth, Rosenkranz moved St. Paul to teach at the Minnesota Art School of the St. Paul Institute.

He did not stay in that city permanently either. In September 1927 he received the most exciting and challenging commission of his life—an assignment for the American Museum of Natural History in New York. He accompanied a group of hunters led by the New York sportsman Arthur Barney to India, Burma, Nepal, and Africa to capture animals native to those areas for exhibition in the museum. Rosenkranz was to sketch the habitats of the animals in order to paint the backgrounds of the displays when they were later mounted in the museum.

Rosenkranz took to the assignment with enthusiasm. He was gone for eight months and in that time journeyed thirty-two thousand miles through Africa and the Far East, making more than a hundred oil sketches and detailed studies of local trees and flowers. The expedition even brought back dirt and plant specimens from the jungles to New York to make the mountings realistic. The expedition was a major undertaking and well equipped. On one hunt in Nepal, for example, the party was organized with the hunters, fourteen elephants, and four hundred bearers. They bagged five tigers, several panthers, and numerous smaller animals, while Rosenkranz watched the hunt, making many sketches of it, from a howdah, or covered pavilionlike seat on the back of an elephant. Besides the sketches, the trip supplied the artist with enough anecdotes of his adventure to last him for the rest of his life. He particularly liked to recount the time when he was sketching the view between a great drove of baboons and their waterhole near Lake Tanganyika. The baboons climbed on a nearby rock and began to scold him, hurling simian shrieks and imprecations at the artist until he moved away. Or the time when he and some of the other hunters were lost in the bush near Mount Kenya for three hours while lions roared all around them.[1] This gave him, Rosenkranz later said, the biggest thrill of the entire trip.

The commission for the American Museum of Natural History led to a later assignment for the habitat

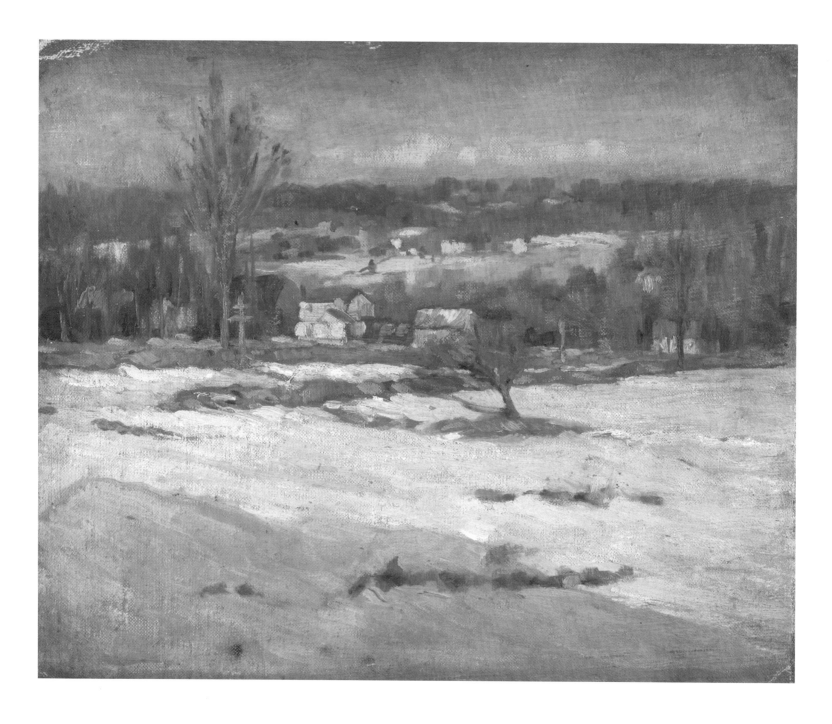

Untitled (Winter Landscape), undated
Oil on panel
13″ x 15¹/₂″
Private Collection

groups at the Academy of Natural Sciences in Philadelphia in 1936. For his work there, however, Rosenkranz had to rely on photographs and rough sketches brought back by the hunters for his background painting of an Alaskan scene for a display of an enormous bull moose. As a true "plein air" painter, he admitted rather wistfully, that "of course, it would be better for me to go with the hunters to see the scenery I am to reproduce in oils,"[2] but the limited funds of the academy made such a trip impossible.

The many landscapes that Rosenkranz painted around Duluth before his habitat mural commissions and his adventures in the wilds of Africa and Asia are far more calm and peaceful. A typical example, and one that incorporates the Impressionist style, is a small, untitled winter scene of unknown date. The broad brush strokes heavily laden with pigment are highly Impressionistic. So is the broken color technique in which touches of pure color are dabbed onto the canvas. Moreover the permutations of white, as an expression of light, are noticeably present, for this was quite important to both the European and American Impressionists. Ultimately they dissolved white light into the components of the color spectrum, which they applied to the surface of the canvas. Indeed, just before Impressionism was adopted by American artists, as art historian William Gerdts pointed out, a concern already existed for the depiction of white itself. In 1886 *Art Amateur* published an article that stated, "The conquest of white is a problem every painter yearns to solve. It is regarded as the highest technical achievement to render white textures in high light and temperate shade with approximate truth."[3] The empty foreground, covered with snow, demonstrates that Rosenkranz, too, was seeking "the approximate truth" of a partly shadowed snowy scene in subtle gradations of white and gray. The houses that appear in the middle and far distance, surrounded by bare winter trees, add a note of color, albeit a subdued one, to the white landscape.

Late in life, Rosenkranz returned to his hometown of Hammondsport. He died there on May 4, 1959.

NOTES

1. *St. Paul Pioneer Press*, September 2, 1928.
2. *Evening Public Ledger* (Philadelphia), July 31, 1936.
3. William H. Gerdts, *American Impressionism* (New York: Abbeville Press, 1984), 20.

ADA AUGUSTA WOLFE
1878–1945

Old Mill at Champlin, Minnesota, November 1933
Oil on canvas
16″ x 20″
Minnesota Historical Society

*I*MPRESSIONISM WAS A METHOD Ada Wolfe used as a means to an end rather than as an end in itself, for she maintained that she was never a slave to a manner or theory. Throughout her life she was an independent spirit, who not only refused to be classified as belonging to one school or another but who also hated what she saw as a form of intellectual dishonesty in art—sentimentality.[1] She sought a virile strength in her paintings, and her goal was to make her work, at all times, broad and simple.

Ada Augusta Wolfe was born in Oakland, California, on May 7, 1878. As a girl of eleven she was brought to Minneapolis where she later enrolled at the Minneapolis School of Art. There she studied under its director, Robert Koehler, and also with Gustave Schlegel and Gustave Goetsch. After her studies, she ventured eastward to New York City to study at the Art Students League under William Merritt Chase, Frank Vincent, and Luis Mora.

It is interesting to note that at this time Wolfe's favorite painters were the Dutch artist, Rembrandt, who was universally admired, and the French post-Impressionist, Paul Cezanne, who had not yet made a strong impression on American collectors, painters, and museum curators. Nevertheless, in spite of her admiration for Cezanne, she later told an interviewer that she was not sure "whether I am a modernist, but that the modern painters had found something in art that the rest of us have been looking for, freedom and breadth of expression not found before."[2] Art, she maintained, "above everything else, needs absolute freedom for its growth. If you want to be a painter, then first be a rebel against anything which has a tendency to enslave you. Your attitude of mind is what counts."[3] This statement is, of course, not exactly a ringing endorsement of the Impressionist movement. In fact, Wolfe was one of the Minnesota artists who received Impressionism with a certain degree of ambivalence.

A painting she had done early in her career, *Sails on Lake Minnetonka* that had won a major prize from the Minnesota State Art Society in 1914, has more of Whistler's influence than the traditional Impressionism of Monet or Renoir. By 1933 when she painted *Old Mill at Champlin*, although she was certainly influenced by Impressionism, she seems to have sailed right over it, to embrace instead the post-Impressionist style that followed. The strong colors and bold, almost tangible brush strokes of the painting are, of course, an outgrowth of Impressionism but even more daring. A blue mill with a red roof appears beyond a golden field, all of which seem to have emerged on the canvas spontaneously, so immediate and apparently unpremeditated is their impact. The Impressionists' broken color technique is carried one step further here, with the primary colors of red, yellow, and an intense blue vigorously applied to the canvas with striking assurance. Wolfe also departed from Impressionism's traditional color palette since she used black in the composition to strengthen the forms of the trees that frame the old mill.

In addition to devoting herself to painting the scene around her, Wolfe also taught art in the Minneapolis schools. She occasionally displayed her work in local exhibitions, but her life was, by and large, a quiet, uneventful one. She bought a house at 2007 Willow Avenue North and lived there until she died on October 4, 1945, survived only by two nieces.

NOTES

1. Gladys M. Hamblin, "Ada Wolfe, Local Artist, Says She Hates Sentiment in Art," *Minneapolis Tribune*, April 2, 1918, Art sec., p. 1.
2. Elizabeth McLeod Jones, "Minneapolis Shown Painters' Paradise by Work of Artists," *Minneapolis Tribune*, December 9, 1917, Art sec.
3. Hamblin, "Ada Wolfe."

Sails on Lake Minnetonka, 1914
by Ada Wolfe
Oil on canvas
38″ x 48″
Minnesota Historical Society

Boyce, William G. *David Ericson.* Duluth: University of Minnesota at Duluth, 1963.

Brennan, Anne G. *Elisabeth Augusta Chant.* Wilmington, N.C.: St. John's Museum of Art, 1993.

Brewer, Nicholas. *Trails of a Paintbrush.* Boston: Christopher Publishing House, 1938.

Brown County Historical Society Museum. *Anton Gág, Impressions of an Immigrant.* New Ulm, 1986.

Brown, C. Reynold, Joseph Rusling Meeker. *Images of the Mississippi Delta.* Montgomery, Ala.: Museum of Fine Arts, 1981.

Catlin, George. *North American Indians, Being Letters and Notes on Their Manners and Customs, Written During Eight Years Travel Amongst the Wildest Tribes of Indians in North America,* 2 vols. London, 1842; reprint, Edinburgh, 1926.

Coen, Rena Neumann. *In the Mainstream: The Art of Alexis Jean Fournier.* St. Cloud, Minn.: North Star Press, 1985.

_____. *Painting and Sculpture in Minnesota, 1820–1914.* Minneapolis: University of Minnesota Press, 1976.

Danforth Museum of American Art. *On the Threshold of Modern Design: The Arts and Crafts Movement in America.* Framingham, Mass., 1991.

Edwards, Lee. "The Life and Career of Jerome B. Thompson," *Art Journal* 14 (Autumn 1982).

Flexner, James Thomas. *That Wilder Image: The Painting of America's Native School from Thomas Cole to Winslow Homer.* Boston: Little Brown, 1962.

Gerdts, William H. *American Impressionism.* New York: Abbeville Press, 1984.

_____. *Art Across America.* New York: Abbeville Press, 1990.

Hills, Patricia. *The Painters' America: Rural and Urban Life, 1810–1910.* New York: Praeger Publishing Co., 1974.

_____. *Turn of the Century America.* New York: Whitney Museum of American Art, 1977.

McLanathan, Richard. *The American Tradition in the Arts.* New York: Harcourt Brace and World, Inc., 1968.

Merrill, Peter C. "Robert Koehler, German-American Artist in Minnesota," *Hennepin County History.* 47, no. 3 (Summer 1988).

Nelson, Marion J. *Herbjørn Gausta, Norwegian-American Painter.* Studies in Scandinavian-American Interrelations 3. Oslo: Universitetsforlaget, 1971.

Nemo, Pat. *"Nicholas R. Brewer, A Passion for Art," The Magazine of the University of St. Thomas,* 10, no. 2 (Spring 1944): 19–26.

Novak, Barbara. *American Painting of the Ninteenth Century.* New York: Praeger Publishing Co., 1969.

O'Sullivan, Thomas. "Robert Koehler and Painting in Minnesota" in *Art and Life on the Upper Mississippi, 1890–1915,* ed. Michael Conforti. Newark: University of Delaware Press, 1994.

Sweeney, J. Gray. *American Painting at the Tweed Museum and Glensheen.* Duluth: University of Minnesota at Duluth, 1982.

Truettner, William J. *The Natural Man Observed: A Study of Catlin's Indian Gallery.* Washington, D.C.: Smithsonian Institution Press, 1979.

University of Minnesota. *American Painting and Sculpture in the University Art Museum Collection.* Minneapolis, 1968.

Works Projects Administration Writers Project. *The Bohemian Flats.* Minneapolis: University of Minnesota Press, 1941.

Zelle, Carole. *The Le Duc-Simmons House, Hastings, Minnesota.* St. Paul: Minnesota Historical Society, 1989.

MINNESOTA IMPRESSIONISTS

Designed by Barbara J. Arney
Stillwater, Minnesota

Typeface is Palatino

Printed on 100 lb. Patina Matte Text

WITHDRAWN